IMAGES
of America

OLD TACOMA

IMAGES
of America

OLD TACOMA

Caroline Gallacci and the
Tacoma Historical Society

ARCADIA
PUBLISHING

Copyright © 2006 by Caroline Gallacci and the Tacoma Historical Society
ISBN 978-0-7385-3103-8

Published by Arcadia Publishing
Charleston, South Carolina

Printed in the United States of America

Library of Congress Catalog Card Number: 2005936259

For all general information contact Arcadia Publishing at:
Telephone 843-853-2070
Fax 843-853-0044
E-mail sales@arcadiapublishing.com
For customer service and orders:
Toll-Free 1-888-313-2665

Visit us on the Internet at www.arcadiapublishing.com

This work is dedicated to Ron Karabaich, who had the good sense to preserve the history of his countrymen and neighborhood. Without him, this portrait of Old Tacoma would not exist.

CONTENTS

ACKNOWLEDGMENTS

Herbert Hunt was the first to write about the history of Tacoma, and historians today still use his work as a guide when telling the story. Murray Morgan, in his *Puget's Sound*, published in 1979, provided additional detail thanks to his access to the Carr family papers. J. N. Nerheim's *History of the Lumber Mills of Old Town* is particularly useful in putting the complex history of this industry into order. Besides histories of this nature, newspaper accounts, city directories, and the Sanborn insurance maps are crucial resources when writing the history of Old Tacoma.

Beyond all this, however, are people's memories and their photographs, along with their collective willingness to share their experiences. There are too many to list here, but the appearance of Ron Karabaich and his Old Town Photo Studio in 1973 became a magnet for the neighborhood's old-timers. Without these people, and Ron, this history could never have been written—indeed, there would be less of the story to tell.

The people at the Tacoma Public Library deserve praise for their custodianship of priceless records and photographs, clipping files, and especially the computerized housing index developed by Brian Kamens. Thomas R. Stenger, now a city councilman but always the historian, has graciously allowed the use of his Thomas H. Rutter photographs. The Ursich family graciously allowed me to use some of their photographs. Roger Edwards reminded me of the unique links between Salmon Beach and Old Tacoma. Finally, I wish to thank the Tacoma Historical Society for sponsoring this history.

INTRODUCTION

The history of Old Tacoma is a complex mixture of what might have been and what it actually became. When Job Carr arrived in 1864, he had dreams of a Northern Pacific railroad terminus that would enhance both his and his son's property. However, by the time Job Carr died in 1887, even he knew Tacoma City was not going to be the place he envisioned. By that time, the railroad company had located the terminus two miles away and the residents of Tacoma City had been politically absorbed into the broader jurisdiction of the City of Tacoma. Job Carr's dream was now simply Old Tacoma.

A neighborhood evolved rather than a city. The purpose of this history is to show some of the episodes and people responsible for the creation of this unique community. The first chapter introduces the reader to Old Tacoma's beginnings, a time when it was called Tacoma City and voters had their own separate government. It was also a time when small industries emerged along the south shore of Commencement Bay. There was maritime activity as well, and along with it a certain wildness giving credence to the area's "colorful" past legacy of saloons and prostitution.

While seamen frequented the places of opportunity along Old Tacoma's Main Street, another type of community was also underway, related specifically to their relationship with Native Americans. The Puyallup Tribe, after all, lived here long before the arrival of Job Carr. Treaties ultimately established a reservation that included, in part, the Puyallup River delta. Maritime commerce, therefore, was confined to the south shore of Commencement Bay. Old Tacoma, as the one area with direct access to the water, was to economically benefit from this particular circumstance.

The south shore of Commencement Bay became Tacoma's first port, one that stretched from the Thea Foss Waterway to Point Defiance. The Old Tacoma neighborhood that took shape as a result of this development is illustrated in Chapter Two, where the reader is able to watch the community grow from unplanned disarray to a neighborhood of families supported by a business district and shoreline industry. Chapters Four and Five document life along the shoreline.

Old Tacoma was an ethnically and racially diverse neighborhood, a matter discussed in Chapter Three. Native American, African American, Jewish, and Asian families were all of part of the community landscape at one time or another. However, the most dominant peoples by far were the Scandinavians and the Croatians, both possessing a seafaring heritage that drew them to Puget Sound. The Croatians established their own fraternal and benevolent organization in Old Tacoma and excelled as boat builders. Scandinavians and Croatians worked together as fishermen.

This story ends with a collection of images designed to show both continuity and change within the Old Tacoma neighborhood. Periodically, early newspapers would report on striking changes afoot that suggested maybe Old Tacoma should consider changing its name to New Tacoma. For example, in 1918, Peter David's Spar Tavern building was lauded as the first step in neighborhood modernization. And while change was always a constant, so too was the neighborhood's insistence on preservation through both marking important sites and creating landmarks of others. What you see today is always what Old Tacoma has been: some things were always changing, and some things will always remain the same.

One

THE BEGINNINGS

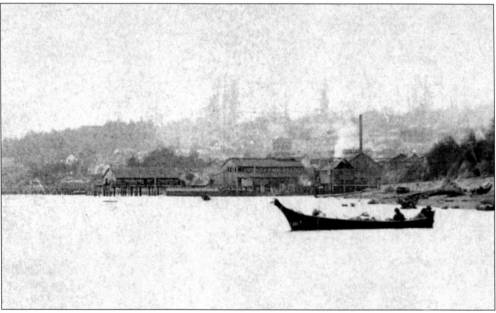

NATIVE AMERICANS ON COMMENCEMENT BAY. Early maps of Commencement Bay show the waters off Old Tacoma as a favored fishing area for the Puyallup tribe of Indians. With American settlement came treaties and the creation of the Puyallup Indian Reservation, located at the head of Commencement Bay. For almost a decade after federal officials signed the treaty, the Puyallup Reservation was the only settlement in the area, one that included a church, a Native American cemetery, and a physician. Job Carr stayed at the reservation while deciding where to establish his land claim.

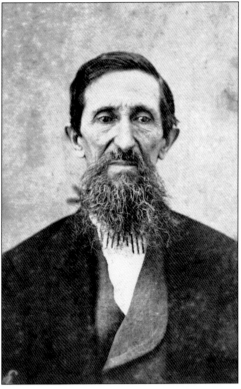

JOB CARR. In 1864, soon after his discharge from the Union Army, Job Carr learned of a new transcontinental railroad line that was to extend from Lake Superior to Puget Sound. He headed west with a hope to locate the terminus of the Northern Pacific Railroad. When he saw a natural draw sloping gently into Commencement Bay, he shouted, "Eureka! Eureka!" and rushed to the Olympia land office to file a preemption claim.

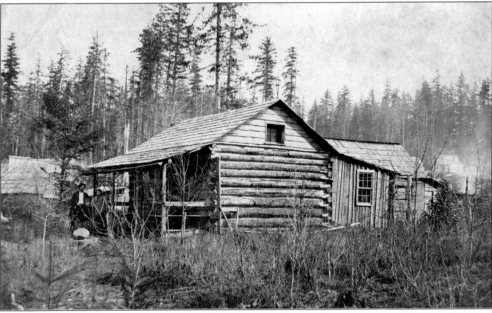

JOB CARR'S CABIN. Before the year ended, Job Carr had built a cabin and enticed his sons, Howard and Anthony, to join him. The brothers, who also filed claims surrounding their father's, were soon joined by sister Marietta. The cabin became a community center for new settlers, and, in 1869, became the Tacoma City post office. Job Carr was the first postmaster, justice of the peace, and in 1874, the town's first mayor.

ANTHONY CARR, OLD TACOMA'S FIRST PHOTOGRAPHER. Anthony's interest in photography began during the Civil War when he was an intelligence officer sent behind enemy lines to record the topography. He brought his cameras west and began to document the creation of Job Carr's settlement. In 1869, he married Josie Byrd, whose family had settled several miles south of Commencement Bay.

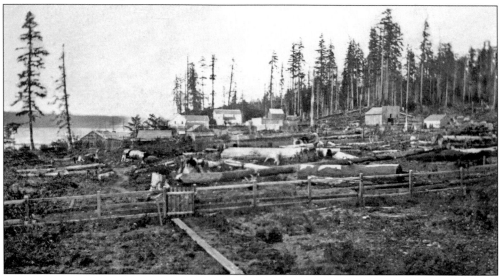

THE BEGINNINGS OF TACOMA CITY. In order to acquire his preemption claim, the Carrs had to establish a farm, as seen in the foreground of this image photographed by Anthony Carr, looking southeast from near Job Carr's cabin. In the distance are the buildings that formed the nucleus of the new town.

11

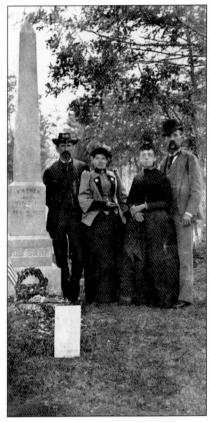

Job Carr Memorial in Tacoma Cemetery. By the time Job died in 1887, he had been mayor of Tacoma City twice, had formed a water company, and had filed a Homestead Claim south of Tacoma City. Here, his family poses by Job's cemetery marker: Anthony and his wife, Josie, are on the left; Howard and his wife, Jane E. Bradley, are on the right.

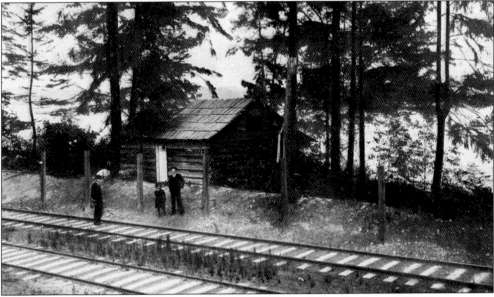

Preserving Old Tacoma's First Residence. During the early years of the 20th century, Tacomans moved to save the Job Carr cabin, reconstructing it in Point Defiance Park. In this image, it is situated adjacent to the streetcar lines running from Tacoma to the park. The site became one of the city's first tourist attractions.

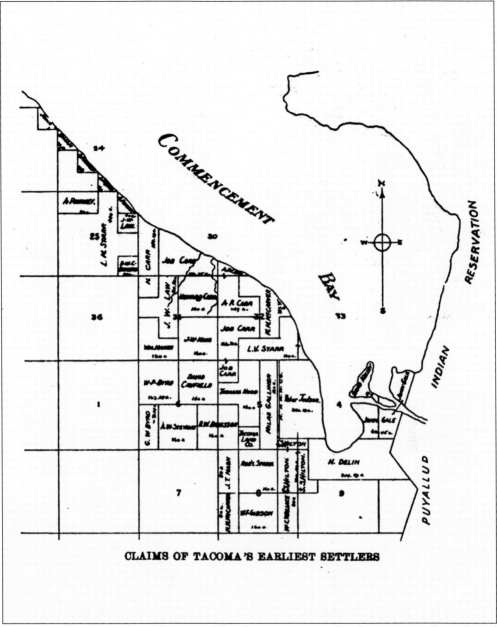

CLAIMS OF TACOMA'S EARLIEST SETTLERS

CLAIMS OF TACOMA'S FIRST SETTLERS. The plan to create a railroad terminus on Puget Sound lured land speculators to the area even before the Northern Pacific Railroad Company had announced a location. The Carr family was the first to arrive. However, by 1873, as this map shows, most of what became both Old and New Tacoma had been acquired by the city's first land developers. Not pictured on the map is the land claim of Portland, Oregon's William Ladd, located adjacent to Point Defiance. With rumors afloat in 1869 that Ladd intended to plat his claim and name it "Tacoma," Anthony Carr rushed to the auditor's office with a "Tacoma" plat of his own, one located near the present intersection of North Starr and Twenty-seventh. Morton Matthew McCarver, whose story follows, also created a "Tacoma" plat at the same time. Thus, confusion reigned until McCarver changed the name of his development to "Tacoma City."

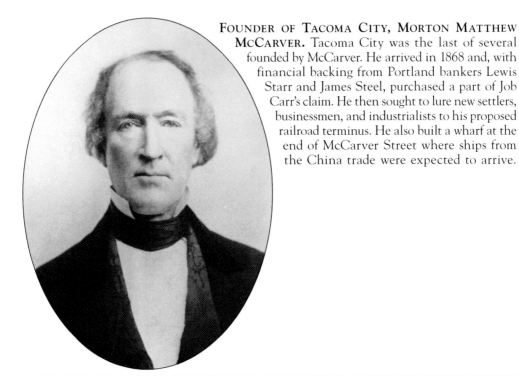

FOUNDER OF TACOMA CITY, MORTON MATTHEW McCARVER. Tacoma City was the last of several founded by McCarver. He arrived in 1868 and, with financial backing from Portland bankers Lewis Starr and James Steel, purchased a part of Job Carr's claim. He then sought to lure new settlers, businessmen, and industrialists to his proposed railroad terminus. He also built a wharf at the end of McCarver Street where ships from the China trade were expected to arrive.

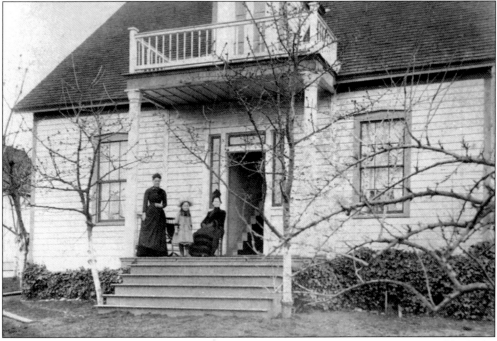

McCARVER HOUSE FRONT PORCH. McCarver brought his family to Tacoma City and built the first wood frame house on Commencement Bay, one located at the corner of present-day North McCarver and Twenty-eighth. It is not known who is gracing the front porch in this photograph, but one of the daughters pictured here married *Seattle Post-Intelligencer* founder Thomas Prosch. Sitting on the right could be McCarver's wife, Julia.

14

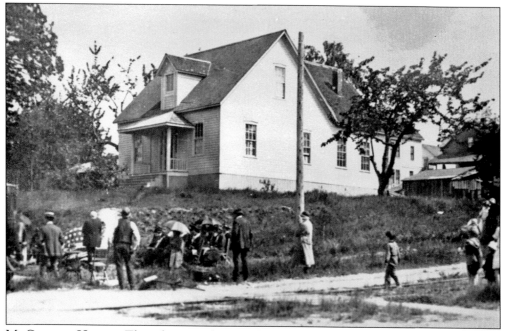

McCarver House. This photograph provides a full spectrum of the house, along with surviving trees from McCarver's orchard. He brought the seedlings from his Oregon City house where he had developed a transparency uniquely his own. This was home for the rest of his life, one that ended in 1875 following a venture into eastern Pierce County in search of coal.

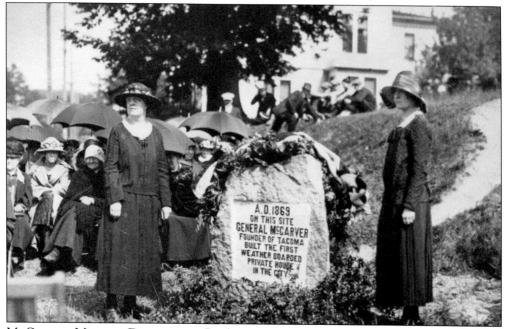

McCarver Marker Dedication. By the 1920s, Tacomans began to realize the historical importance of Old Tacoma and began a program to identify all the city's "firsts." A women's organization promoted the endeavor and raised the funds for markers. Here, an unidentified group proudly poses in front of the McCarver marker when it was unveiled.

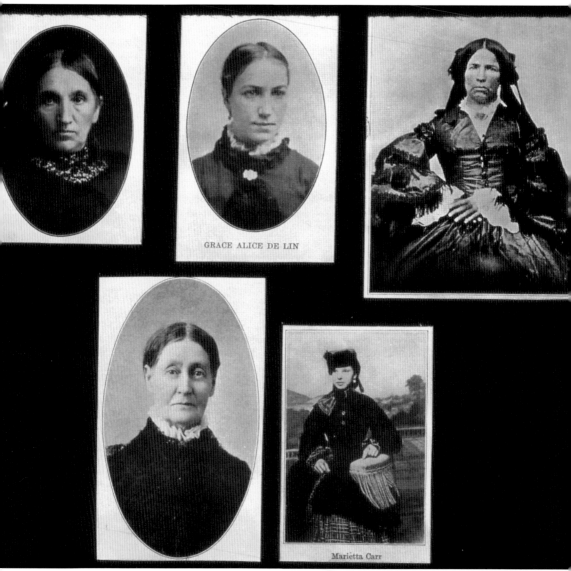

GRACE ALICE DE LIN

Marietta Carr

FOUNDING MOTHERS OF TACOMA. Even before the arrival of Job Carr there had been settlement along the south shore of Commencement Bay. Both the DeLin and Judson families filed donation land claims near the head of the bay in the mid-1850s but left them following Native American hostilities. Even so, the wives and daughters of these families must be honored as the first women to encounter the future town site Pictured, from left to right (top row) are Gertrude DeLin (wife of Nicholas DeLin), her daughter Grace, and Anna Judson (wife of Peter Judson); and (bottom row, in Tacoma City) the wife and daughter of the town's two founders, Julia McCarver and Marietta Carr, respectively. There were few children in 1869 when Pierce County School District No. 11 was formed. When the one-room log schoolhouse, located on the southwest corner of present-day North Starr and Twenty-eighth, was ready, there were only 13 pupils. Virginia McCarver was the second schoolteacher.

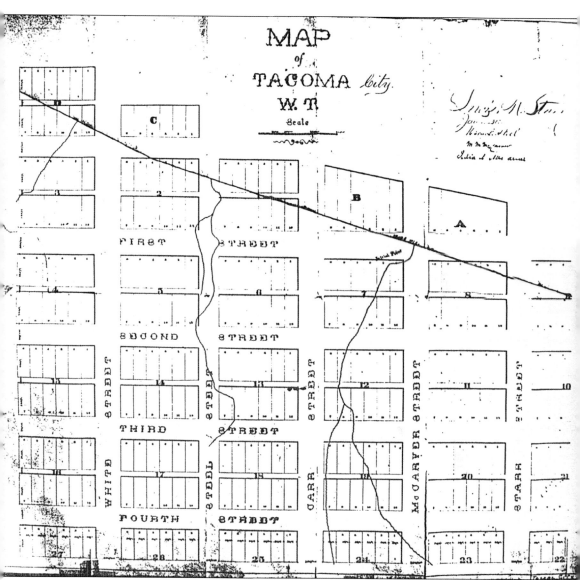

OFFICIAL MAP OF TACOMA CITY, 1869. This street plat symbolizes the hopes and dreams of Job Carr and M. M. McCarver as they continued to promote Tacoma City as the Northern Pacific Railroad terminus. Land had to be cleared, streets graded, and houses built in order to transform these lines on a map into a living town. By 1873, when railroad officials toured Puget Sound to locate the terminus, McCarver was sure that Tacoma City was to be the place. He was close. In July of that year, the railroad company selected a site two miles south of McCarver's development. According to son-in-law Thomas Prosch, McCarver was devastated: "It did not occur to him that the railroad men . . . would use the means he had given them to inflict upon him their hardest blows, that they would endeavor to destroy his town by building a rival town two miles away, by robbing it of its name . . . and by these and similar methods ruin him and those with him in the town he had projected and fathered."

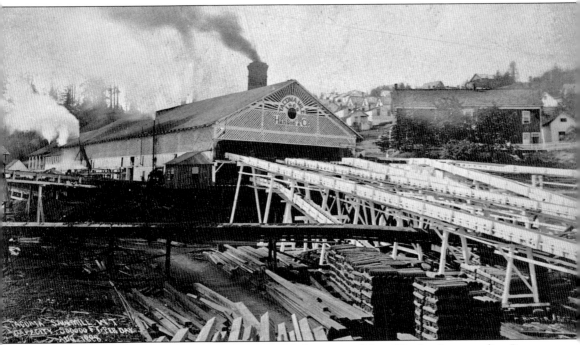

TACOMA CITY'S FIRST INDUSTRY, THE HANSON, ACKERSON MILL. The land surrounding Puget Sound was covered with dense forests of trees, and with American settlement came lumber barons from all parts of the country. Some were small operations, such as Nicholas DeLin's, whose 1850s sawmill at the head of Commencement Bay led to the logging of the Tacoma City townsite even before Job Carr arrived. The mining fields of California and Nevada were the major market for Puget Sound timber at this time. Morton Matthew McCarver decided a lumber mill located at Tacoma City was necessary to prove to Northern Pacific Railroad officials that his townsite was suitable for the terminus. Therefore, when he learned San Franciscan Charles Hanson was touring Puget Sound in search of a mill site, he convinced him that Tacoma City was such a place. This image shows the mill under full operation. The hill to the left was "mill town," where the workers lived. The company store is to the right of the sawmill.

STEELE HOTEL. In 1869, Janet Elder Steele established the first hotel in Tacoma City. Located on Second Street, it contained 24 rooms and developed a reputation for having the cleanest sheets and best food of any located between Olympia and Victoria, British Columbia. Janet was a shrewd businesswoman. Later on, when the development of New Tacoma was underway, she traded her favorite pearl-handled revolver for two city lots downtown.

STEELE HOTEL MARKER. The site of Janet Steele's hotel was one of the marked firsts in the city. This time, artist Alonzo Victor Lewis was retained to design the memorial. As a sculptor, Lewis was well known. He designed the World War I memorial on the Washington State capitol grounds, the Ezra Meeker statue in Puyallup, and the Abraham Lincoln statue gracing the grounds of one of Tacoma's high schools. The marker is no longer there.

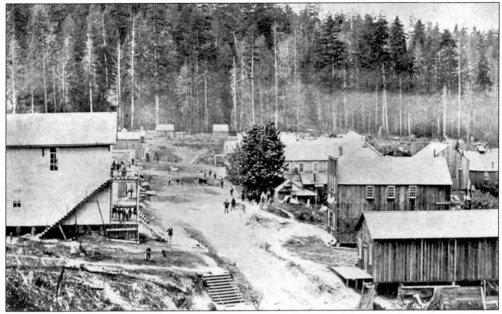

VIEW OF TACOMA CITY, 1871. This is a photograph looking roughly west, where Second Street (now North Thirtieth) ends near McCarver. The tree in the center marks the location of the Steele Hotel. The large building to the left included businesses on the first floor, one of the earliest being a saloon, with a meeting hall above. Freemasons used this space when the first lodge organized in 1873.

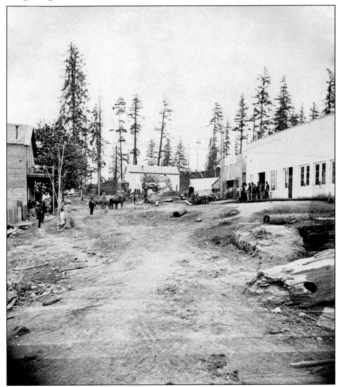

EASTERN EDGE OF TACOMA CITY IN THE 1870S. In the 1870s, development eastward along the town's main street ended at North Starr, and again the Steele Hotel can be seen, this time on the left. Beyond this image, one would have found the Hanson, Ackerson Mill and company store. This photograph and the one above were most likely seen by the Northern Pacific Railroad officials evaluating the town as a possible terminus.

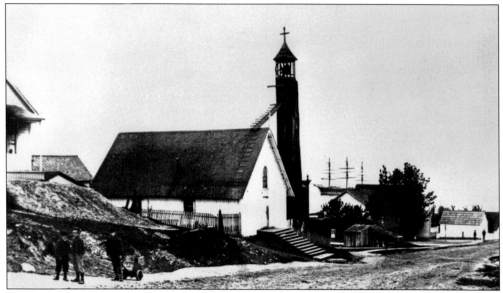

St. Peter's Methodist Episcopal Church, 1873. When news arrived that the railroad terminus was coming to Commencement Bay, locals realized that it was time to build a church. Methodist Episcopal Bishop John Adams Paddock and his wife, Fannie, were also on their way west to minister to the religious needs of the new settlement. Children from Philadelphia donated the bell placed atop a cedar tree, and soon residents were boosting their "oldest bell tower in the world."

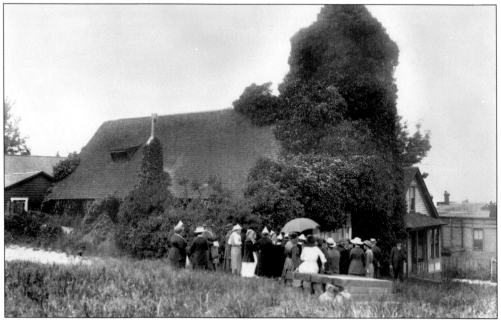

Ivy and St. Peter's Church. Ladies of Old Tacoma planted ivy around the church as a beautification project. Over time, the plant consumed the building, both inside and out. People are gathered here for reasons unknown. However, by the end of the 19th century, St. Peter's was used by many denominations for religious services and was a popular place for holding community meetings. The church survives to this day.

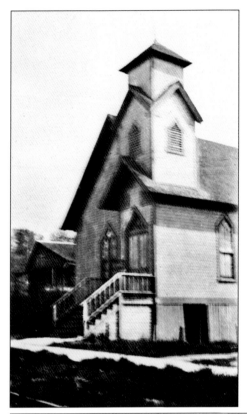

SECOND METHODIST CHURCH. The Second Methodist Episcopal Church was, according to city directories, located at 1132 North Twenty-eighth Street, at least between 1900 and 1920. After that time, Charles and Ingeborg Brown lived at the address and opened the property to boarders. There was a local rumor that church officials closed the church because there were too many "Austrian heathens" in Old Tacoma.

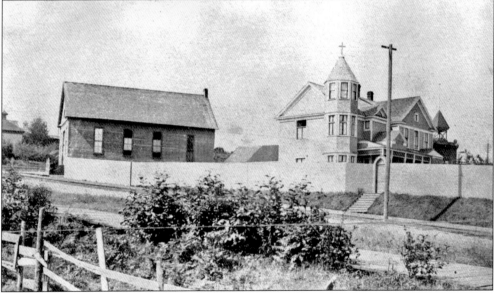

ST. PATRICK'S CATHOLIC CHURCH AND CONVENT SCHOOL. St. Patrick's Parish, under the pastorate of Fr. W. J. Edmonds, was established in 1891 as one of the oldest in the city. In this photograph, the building on the left was the church. In 1899, Acquinas Academy, pictured on the right, was opened by the Dominican Sisters to educate parish girls. The two buildings were located near the corner of North Starr and G Streets.

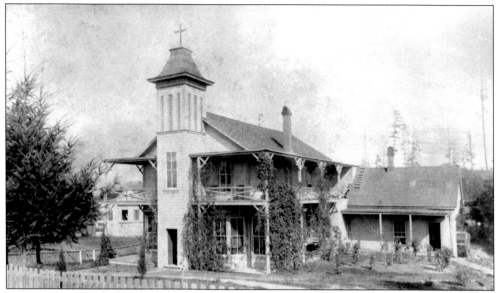

FANNIE PADDOCK HOSPITAL. Fannie Paddock had a dream she shared with the Bishop's home church prior to their departure to Tacoma City. Pictured here is the hospital, located on Starr Street. Parishioner donations accompanied Fannie as the couple moved west. Sadly, she died before arriving at Tacoma City and was never able to see her dream come true. But the hospital was built and named in her honor when dedicated in 1883.

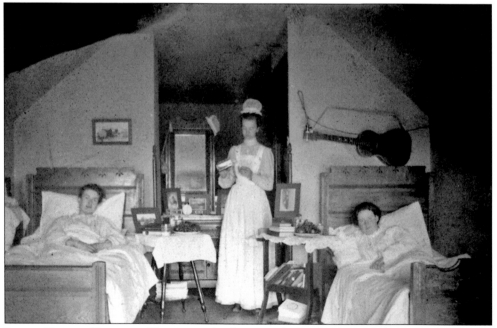

INSIDE FANNIE PADDOCK HOSPITAL. At the time the hospital was dedicated, one Tacoma newspaper reported that the Pierce County government would pay for the health care needs of the poor. This interior view shows some recuperating men in one of the wards. With time, the hospital was built anew on North K Street and renamed Tacoma General Hospital.

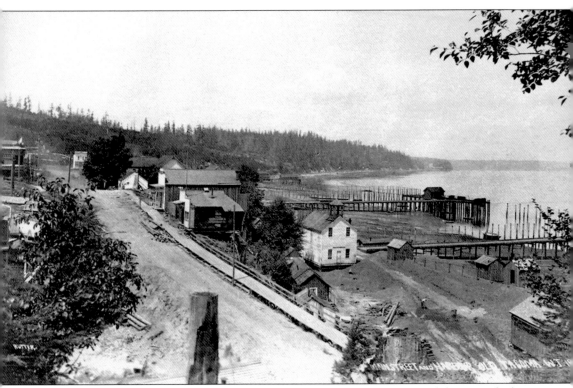

VIEW OF OLD TACOMA, 1888. Early photographer Thomas H. Rutter captured this image looking west along Second Street in 1888, one year before Washington became a state. By this time, the Tacoma City and New Tacoma governments had combined to form the City of Tacoma. From 1884, the community became Old Tacoma, or Old Town. The tree marking the Steele Hotel can be seen near the hump in the street. Beyond this landmark, more land has been cleared since 1871 and the street is beginning to inch its way up the hill, reaching roughly to Carr Street. The settlement looks pretty much like other pioneer towns with its false-front wood frame buildings, wooden sidewalks, and ungraded streets. The building in the center with the cupola was a reading room. Lewis Starr built the wharf leading out to the bay from here; the other was McCarver's, which today is the location of the Old Town Dock.

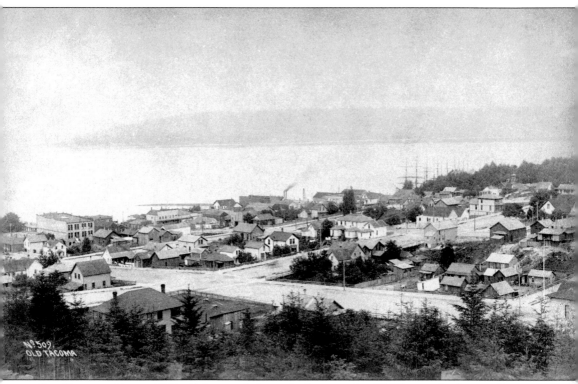

Old Tacoma, Early 1890s. Substantial change had occurred in Old Tacoma by the time Rutter took this eastward-looking photograph. Streets are now graded and soon would be covered with cobblestones and brick. In the distance, one sees the masts of the ships anchored at the Hanson, Ackerson Mill, now called the Tacoma Mill Company. Businesses line the main street marked by the brick building seen on the left. The remainder of the neighborhood is housing with a wide variety of styles, from simple wood shacks to the more elaborate residences built for the families of the businessmen. It was a "walking city" where all the needs of its residents were located close by. The neighborhood remained relatively isolated from the Tacoma developing two miles away. But urban life was about to change with the arrival of the streetcar.

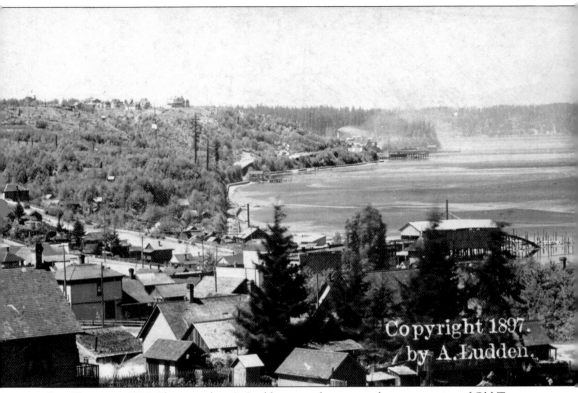

OLD TACOMA, 1897. Photographer A. Ludden provides yet another perspective of Old Tacoma in this late-19th-century photograph. It is yet to be determined where he stood to capture this image, but it might have been looking westward from the site of the Second Methodist Church on North Twenty-eighth Street. The upper part of the photograph shows the results of more land clearing, and up on the hill one can see Allen C. Mason's North End development that is encountered again in the next chapter. Along the shoreline there is the beginnings of a road that ends at the Tacoma Smelter, whose construction began in 1888. The remainder of the image is a compressed view of Old Tacoma. The lower left shows the Zelinsky house still standing on North Twenty-eighth Street west of Starr. Allen C. Mason's brick Pioneer Block is visible in the center behind the fir tree. The building on the shoreline to the right is the Lillis Brothers Lumber Mill, established in 1896. Shortly after Ludden took this photograph, the mill's dock collapsed.

Two

FROM TACOMA CITY TO NEIGHBORHOOD

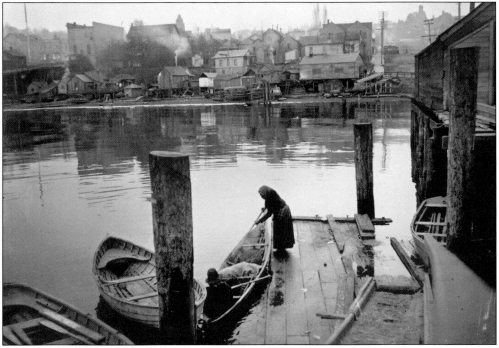

CONTINUING PRESENCE OF NATIVE AMERICANS. A streetcar rounding the bend at North McCarver and Thirtieth Street, with the Lowell School bell tower in the distance, tells us that this Paul Richards photograph was taken at the very end of the 19th century. The shoreline is covered with ramshackle abodes. On the far left, North Starr reaches outward into Commencement Bay where the remnants of the Starr Street wharf are out of view. Also visible is the Old Tacoma jail sitting next to a flag pole constructed in 1898. The photographer is standing on the McCarver Street dock, where mercantile buildings cover the wharf on the right. In the midst of all this development is a Native American couple casting off their canoe following a day of gathering clams along the beach. The view was a common one at the time, since some Native Americans chose to live close to their fishing places along Commencement Bay rather than on the reservation, until Northern Pacific Railroad officials removed them from "their" property and pollution from the mills destroyed the shellfish.

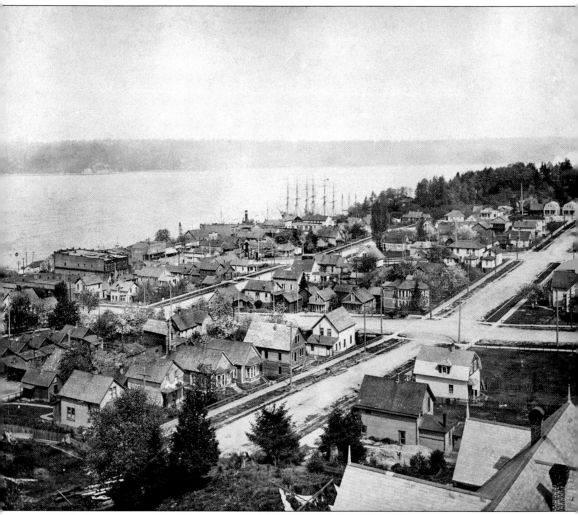

BIRD'S-EYE VIEW OF OLD TACOMA, 1907. Prospect Hill, overlooking Old Tacoma, was a favored location for views of the neighborhood, as this 1907 photograph shows. The most visible intersection is North Carr and Twenty-eighth Street. The rear of the Seamen's Rest can be seen in the left corner where the two streets cross. Grocer Sol and Henrietta Zelinsky lived across from Carr in this house at the time the photograph was taken. The house in the right foreground might be the home of widow Lydia Whelpley; her husband, Horace, established the Old Town Pharmacy. Her one boarder was Edward T. Eva, who eventually owned the North McCarver and Thirtieth Street business. Most of the houses you see in the image are the homes of Scandinavian and Croatian fishermen, flour and lumber mill workers, and occasionally a clerk in one of the main street businesses.

MRS. HANSEN. In the early years of Old Tacoma, a small gulch existed at the eastern end of North Twenty-ninth Street. Here lived a Mrs. Hansen, who posed for this photograph in front of her home sometime during the early years of the 20th century. Living next door, in the 1920s, was laborer Olof and his wife, Hilda Wick, along with ship worker Lawrence Peterson.

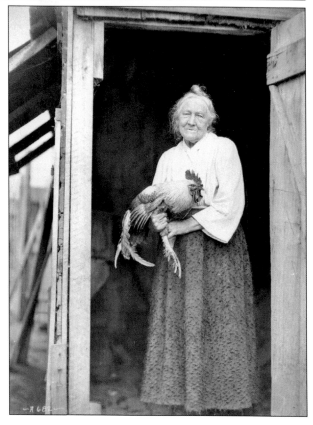

MRS. HAMMER. Old Tacoma was home to a number of women with delightful names. A local bootlegger, for example, was called "Old Woman Seven Skirts" because she hid her booze in layers of skirts. In this photograph, the "Chicken Lady" poses with one of her roosters. She lived on the Carr Street hill near its intersection with Tacoma Avenue North.

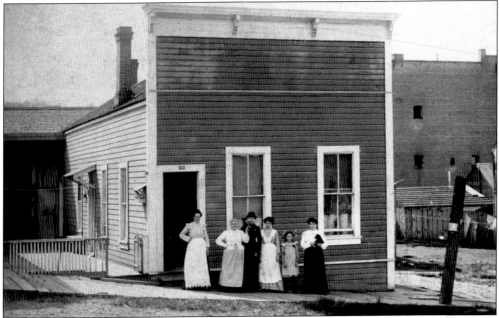

BERG FAMILY. The woman on the far right in this image is Hans Berg's wife, Christine. The remaining women and children are probably other members of the Berg family. The building, located on the west side of McCarver just south of the alley, is typical of many once found in Old Tacoma with a storefront facing the street and living quarters behind.

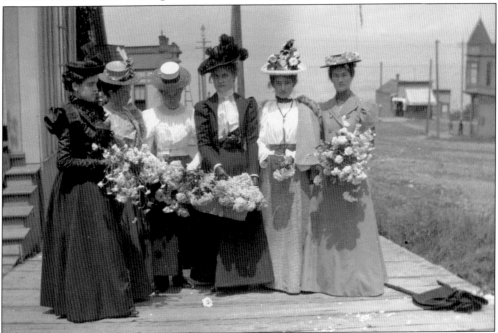

FLOWER LADIES AT ST. PETER'S CHURCH. For some reason, these young ladies are posed in front of St. Peter's church. It is unfortunate that they are unidentified, for their gentility contrasts sharply with the frontier urban landscape of wooden sidewalks and unpaved streets. The Fairview building and Holmes confectionary and cigar store are in the background.

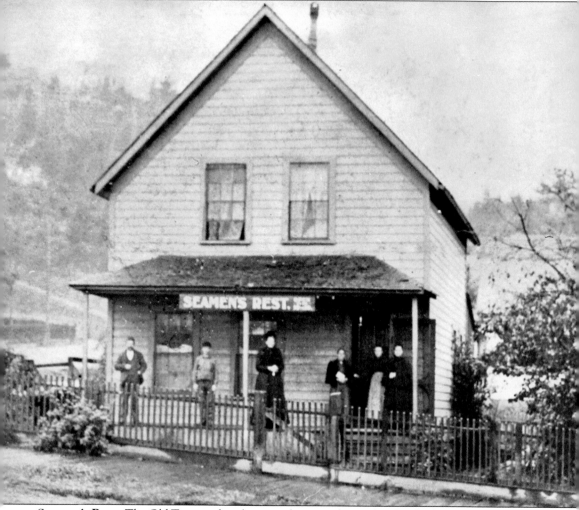

SEAMEN'S REST. The Old Tacoma shoreline was the port of arrival and embarkation for countless sailors and merchant mariners during its formative years, and their presence contributed to the neighborhood's colorful reputation. Old-timers loved to talk about the number of saloons and prostitutes that catered to the seafaring transients. These could be dangerous times too, given the accounts of the Old Tacoma police who dared not patrol the streets alone. Even so, there were sailors who wanted no part of the wild nightlife that Old Tacoma could provide. For these men, Birgitte Funnemark and her daughter Christine provided a haven of rest at 2802 North Carr. Birgitte died in 1919, long after the Seamen's Rest had been closed. Christine lived to 1960, at which time her obituary honored her as one of the founders of the Tacoma Rescue Mission.

WIDOW ERICKSON WITH DAUGHTERS. This photograph probably shows the family of a longshoreman named Ole Erickson. The image points to a major fact of life for Old Tacoma families—work was precarious on the waterfront and oftentimes life was short, thus the neighborhood had its fair share of widows with large families to support.

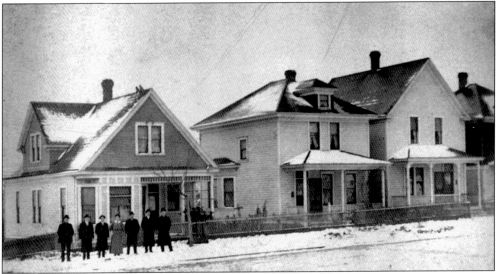

HOUSES ON NORTH TWENTY-SIXTH STREET. This unidentified group is standing on the northeast corner of McCarver and Twenty-sixth Street. Jacob Lind, a laborer for the Tacoma Warehouse and Elevator Company, lived in the house in the background in 1900. Henry Olsen, also a laborer, lived here with his wife, Josephine, by 1910. During the same time, Thomas Sandena, Carl and Selma Olson, and George Alcorn lived next door. Charles Larson, along with John Quever and his wife, Jynne, lived in the house on the right, sometimes with boarders. Larson was a tallyman for the Pacific Shingle Mill. Carl Olson built carriages.

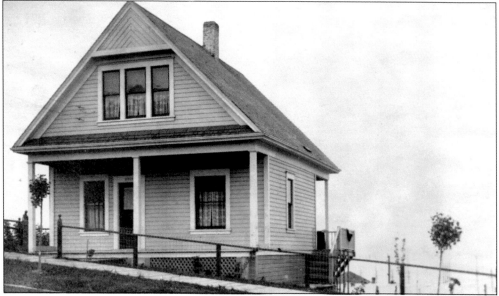

GUSTA CARLSEN HOUSE. This house, located at 2415 North Thirtieth Street, has been a residence for others besides the Carlsens. Boomman Matthew Stephen, wife Julia, and daughter Blanche lived here in the 1920s. Julia provided furnished rooms in the house for workers, including John Watson and his wife, Hazel, and a ship worker named George McDonald.

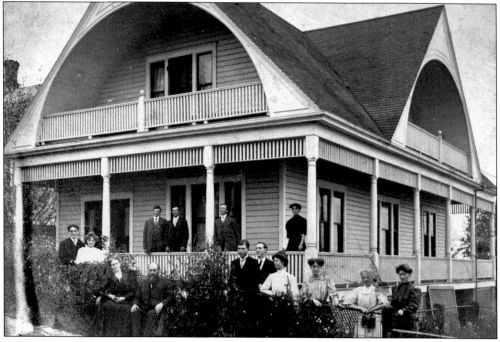

ANDREW A. STRUBSTAD HOUSE. Andrew Strubstad, one of Old Tacoma's boat builders, lived in this house at 2603 North Thirtieth Street with his wife, Gertrude. Pictured here, from left to right, are Clarence Watson, Ellen Watson, unidentified, unidentified, Louis Holm, Annie Hilligoss Strubstad, Gertrude, Andrew, Laars, unidentified, Andrew Strubstad, Flossie, Ida Strubstad Emerick, Jennie, and Gusta Strubstad Carlsen.

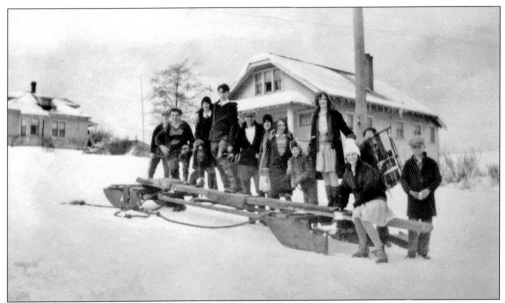

OLD TACOMA BOBSLED. Children played on the streets of Old Tacoma for want of a public park. One of their greatest collective joys in winter during the 1920s and 1930s was "the bob." After the snows fell, the bobsled would be hauled to the top of the Thirtieth Street hill, where boys and girls would climb aboard and float down the hill, stopping only when the sled ran out of steam.

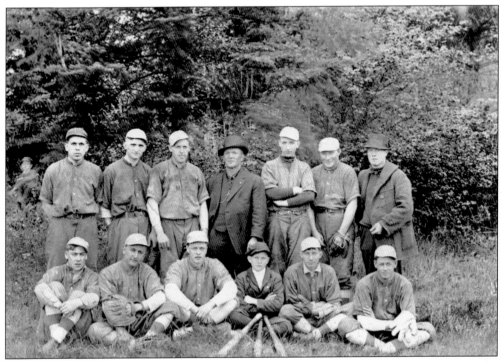

NEIGHBORHOOD BASEBALL. Practically every city, town, and neighborhood in the nation had a baseball team in the days gone by. Old Tacoma was no exception, as this image illustrates.

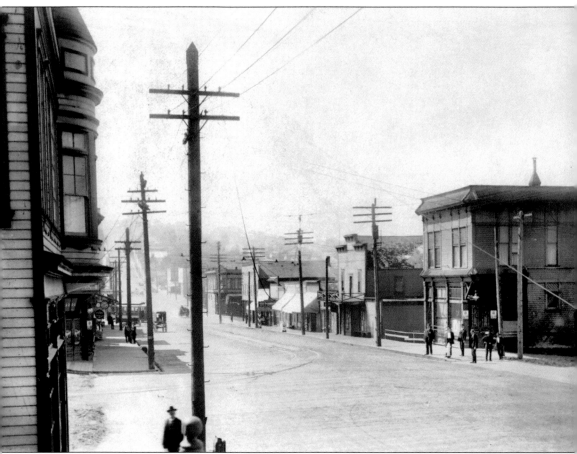

OLD TACOMA AS A STREETCAR SUBURB. By the end of the 19th century, streetcars had arrived in Old Tacoma. In this photograph, a trolley is visible on the left, turning the corner at North Thirtieth Street and McCarver. It would travel east along North Thirtieth to Starr, then turn north past St. Peter's Church to Tacoma Avenue before returning to downtown Tacoma. The streetcar was crucial in linking Old and New Tacoma. Even though the neighborhood was not as isolated as in the past, Main Street still retains its ambiance as a frontier town, as this westward-looking image shows. The group of men on the right is standing in front of the Palace Hotel, which was owned by Sophia Wilbur from the early 1900s into the 1920s.

OLD TACOMA JAIL. While a chauffeured Franklin dominates this photograph of North Thirtieth and Starr Streets, what is more interesting for this history of Old Tacoma is the view behind the two unidentified gentlemen. In the distant right is the Frank N. Holmes cigar store. On the left is the wood-framed, clearly not too secure Old Town jail. This was not the lockup for major criminals, just the place for those who got a little rowdy after time spent in one of the many local saloons.

FAIRVIEW BUILDING AND OWL CAFÉ. This building, located on the southeast corner of Starr and North Thirtieth Streets, has seen many uses over time, but boarders always used the upper floors. Restaurants and saloons under various names and ownerships graced the first floor. The city directory lists the Seaman's Institute and Bethel Reading Room, with Robert S. Stubbs as chaplain, using the building hidden in the trees.

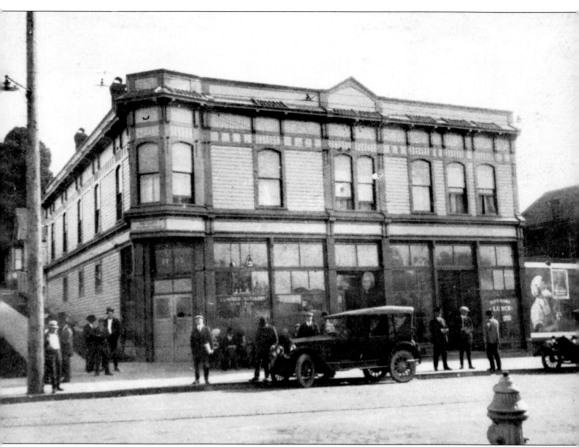

MURPHY BUILDING. Overlooking the southwest corner of Starr and North Thirtieth Streets, the Murphy building was constructed in the 1890s and still survives in Old Tacoma. Boarders lived upstairs with J. W. Garner and Harry Jenkins, offering the furnished rooms between 1908 and 1911. There were various saloons on the first floor at least until 1916, when Washington State legally introduced prohibition. The Resort Saloon was one example. T. H. Thompson, Charles Gord, Robert Hoskins, and Anton Christianson were some of the men associated with saloons at this location. This photograph, taken *c.* 1920s, shows a neighborhood in transition, complete with new automobiles and people waiting for the next streetcar. By now, Beatrice Kerr, the widow of Louis, managed the upstairs furnished rooms still occupied by laborers. The corner entry opened into the Lumber Handlers Union Hall, later to become the Longshoremen's Hall. Both organizations point to the importance of lumber workers and longshoremen within the Old Tacoma neighborhood.

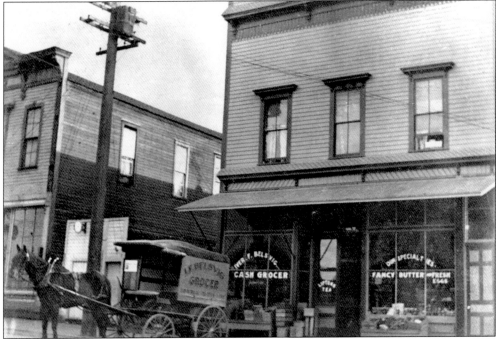

IVER BELSVIG GROCERY STORE. H. I. Mallek had a retail clothing shop at this location during the early years of the 20th century. When he moved his store down the street in 1910, Iver Belsvig and his wife, Amelia, acquired the building for their grocery store. Boarders lived upstairs, including longshoremen Christ Hanson and Edward Wick.

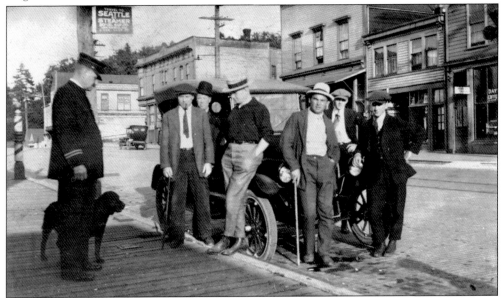

"OLD TOWN COP." Leaning against the car, from left to right, Frank Lavine, unidentified, unidentified, Emil Kurtz, Charles Nudorfer, and Silas Babcock pose with neighborhood policeman Rolf Aune. By the 1920s, when this photograph was taken, the Old Tacoma jail was just a memory. The policeman's life was an easy one by then. A reporter once commented, "His hands clutch no club, nor do they rest upon the butt of a revolver."

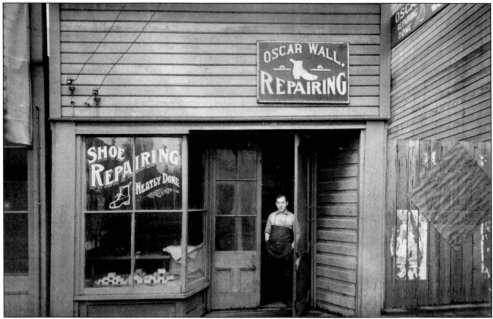

OSCAR WALL SHOE REPAIR. Oscar repaired shoes at his small place of business located at 2109 North Thirtieth Street. Evidently, he also made shoes judging from his entry in the Tacoma city directories. There is also evidence that he acquired the business from a John Wood. The shop was sandwiched between the Palace Hotel, which can be partially seen on the right, and the Grunden barbershop, partially visible on the left.

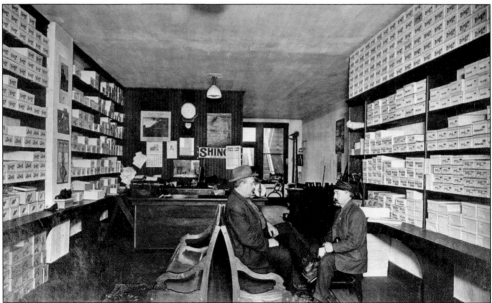

INSIDE ANDREW O. WALL SHOE STORE. By 1900, Andrew Wall was selling boots and shoes in a shop at 2114 North Thirtieth, across the street from Oscar's shoe repair. Around 1916, Andrew died and his widow, Carrie, moved the shop next door. Here one sees Andrew selling shoes to a customer, while wearing a hat, no less. Old Town residents would later visit Anders Anderson and Edwin Wallow's restaurant at this same location.

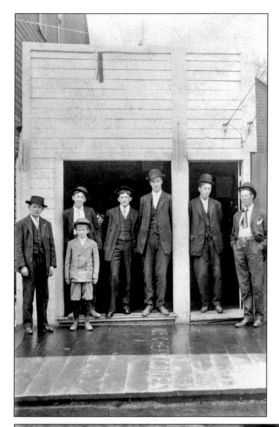

NEIGHBORHOOD SHOOTING GALLERY.
Tucked among the grocery stores and saloons on the south side of North Thirtieth Street, between McCarver and Starr Streets, was this tiny shooting gallery. In this photograph, the tall man in the middle is Edgar "Slim" Lyons. The youngest boy on the left is Cecil Bloomquist. At one time, the building was also used as a movie theater.

FRANK BERRY'S OLD TACOMA SALOON.
Before the present-day Spar, there was the two-story Old Tacoma Saloon. Many of the Berry family were fishermen and Frank longed in the early years of the 20th century to be appointed the state fish commissioner. His lobbying campaign collapsed, however, when the governor learned that the second floor of his saloon was used by "ladies of the night."

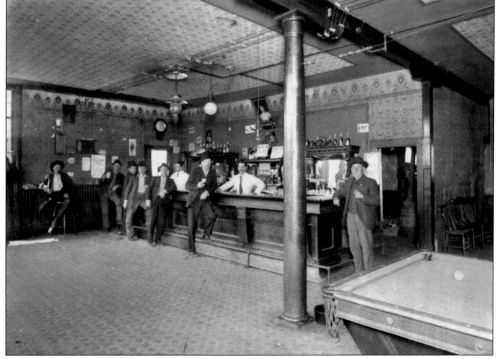

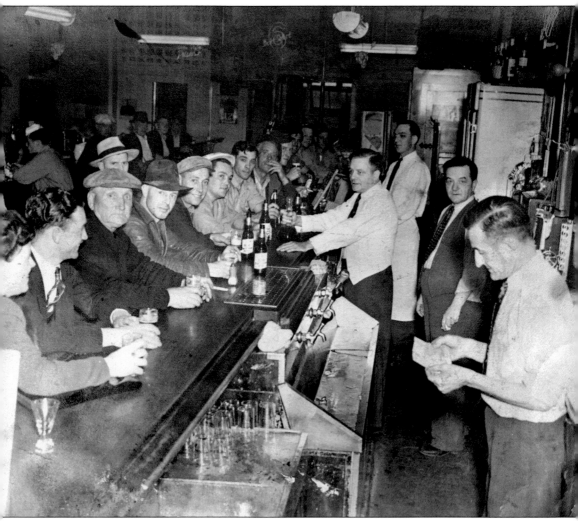

FIRST SPAR TAVERN. Between 1916 and the repeal of Prohibition in 1933, what were once saloons became "soft drink establishments" and local boat builders provided "rum runners" that imported the outlawed beverages from Canada. Gulches were a delight for bootleggers, and Old Tacoma was never really very dry. By 1918, Peter David had acquired Frank Berry's old saloon, tore it down, and built a brick building large enough for two commercial spaces. In one space, the Radonich brothers (Jacob, George, James, John, and Anton) opened the Spar Tavern, and this interior view shows the brothers behind the bar. The Spar still exists at the northeast corner of North Thirtieth and McCarver Streets. As with most Old Tacoma businesses, the second commercial space has had a varied life over the years. One of the first known uses was described as a "fishing headquarters store."

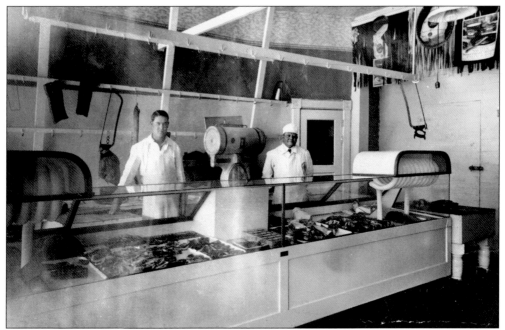

THIEL BUTCHER SHOP. The man on the right is Herman Thiel, who by the 1920s had opened this butcher shop at 2205 North Thirtieth. His helper, George Rule, joins him behind the counter. This was one of several shops providing fresh meat to Old Tacoma residences, a service provided well into the 1970s.

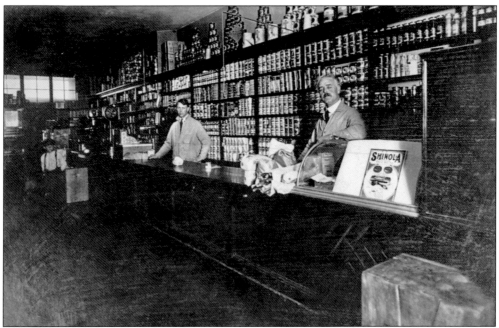

R. P. G. CARVER GROCERY STORE. Roscoe P. G. Carver, no doubt the man in the foreground in this photograph, acquired his grocery experience while working in the Tacoma Mill Company store. By the 1920s, he had acquired Charles Newman's Pioneer Market, located at 2209 North Thirtieth Street. Here Carver and his wife, Hulda, sold groceries, hardware, cordage, and paint.

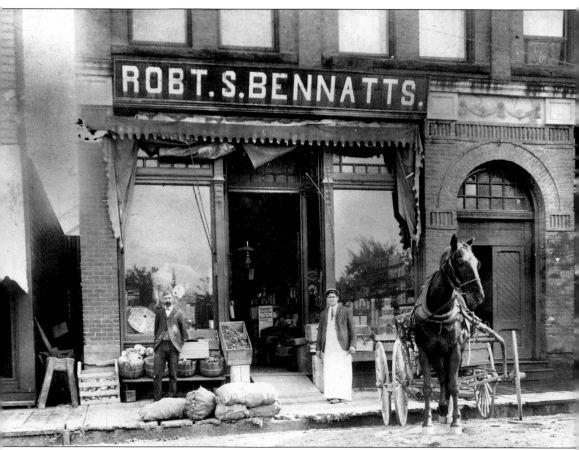

OLD TACOMA'S FIRST BRICK BUILDING. The year 1889 was a pivotal one for Old Tacomans. Edward Fuller, with the financial backing of Allen C. Mason, launched an effort to establish the area as the true terminus of the Northern Pacific Railroad. Fuller located his newspaper *Every Sunday* in Old Town, while Mason began the development of the area around Point Defiance as a new town, with Old Tacoma its commercial core. To inspire local businessmen, Mason constructed the Pioneer Block, a three-story brick building located at 2214–2216 North Thirtieth Street (the present site of the city's substation). One of his first tenants was Robert S. Bennatts, whose grocery story also provided hay, grain, and feed for the neighborhood horses. Sharing the first floor with Bennatts in 1890 were the C. A. Parish hardware store, physician R. F. Brodnax, and real estate agent John N. Conna. The building also had a bowling alley and a Masonic hall during its lifetime, with boarders living in the upper stories. The most well-known tenant was the Butternut Bread Company, who offered "Sunbeam Bread," with E. O. Nichols as proprietor.

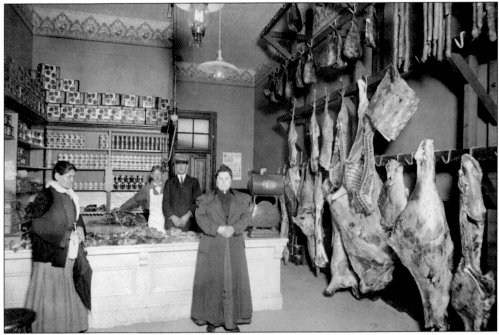

RABASA BROTHERS MARKET. By the beginning of the 20th century, John and Nicholas Rabasa, later joined by brother Anton, began their general merchandise store located at 2224 North Thirtieth Street. This photograph shows the interior of the store with customers in the foreground and one of the Rabasa brothers behind the counter. By the 1920s, the Rabasas had incorporated the business with Nicholas as the president and Frances Rabasa as secretary/treasury.

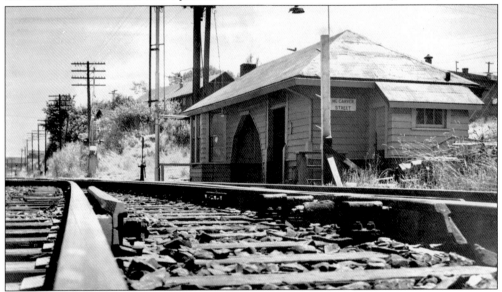

MCCARVER STREET RAILROAD STATION. Originally the main line of the Northern Pacific bypassed Old Tacoma. By 1914, however, the railroad company rerouted the road so that it skirted Puget Sound, went by tunnel underneath Point Defiance, and passed by Old Tacoma on its way to the city's downtown. This image, taken southward along the tracks, shows the station that once sat adjacent to McCarver Street.

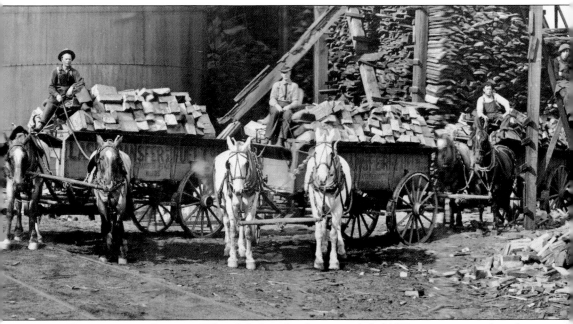

LASH TRANSFER AND EXPRESS. When Job Carr first homesteaded, Old Tacoma was awash with streams, springs, and gulches. Some of the springs were developed into waterworks, with Fuller's Domestic Waterworks located near Carr and Twenty-sixth Streets as the most well known. The gulches bordering both sides of Old Tacoma, Garfield, and Buckley were barriers to expansion. Garfield was consumed early on by the Tacoma Mill Company. Buckley stopped commercial development on the west side until the lower reaches were gradually filled, forming, among other things, the present-day Old Town Playground. Local blacksmith J. T. Magill used the land east of Carr Street, along North Thirtieth Street. By 1907, the Slavonian-American Benevolent Society had constructed its meeting hall just east of the gulch. McKenzie and Sons (also known at different times as the Lash Transfer and Fuel Company as well as the Lash Transfer Company) consumed the remainder of the land. Throughout the early years of the 20th century, McKenzie brothers William, Neil, and Richard ran the business, delivering everything from wood for fuel to horses and wagons for moving.

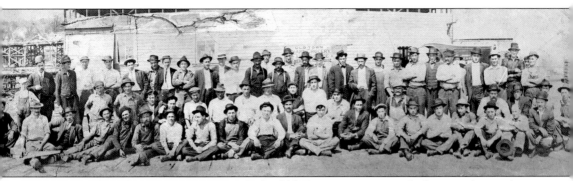

VIEW OF OLD TACOMA, 1913. By 1913, the Old Tacoma community had acquired everything defining a neighborhood: churches, public and private schools, a business district, streetcar service to downtown Tacoma, meeting halls, and—most important—families who lived in the houses built along graded streets. This 1913 image symbolizes the beginnings of change in Old Tacoma shortly before World War I. The truck and the elevated roadway in the distance to the left indicated that the neighborhood is on the eve of the automobile age. Marvin Boland photographed these men posing on the McCarver Street Wharf. Grocer R. P. G. Carver's delivery truck sits behind the men on the right.

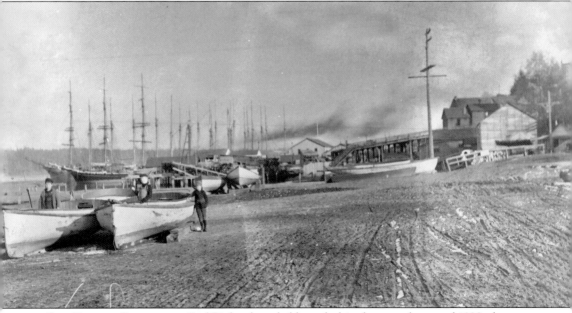

OLD TACOMA SHORELINE. Paul Richards probably took this photograph around 1898, the same time as the one shown at the beginning of this chapter. But where he stood is a mystery. The view is south toward the Tacoma Mill Company and the Starr Street wharf. Children pose by craft that could be boathouse rentals, while tall-masted schooners await their turn at the lumber dock.

Three

ETHNIC COMMUNITIES

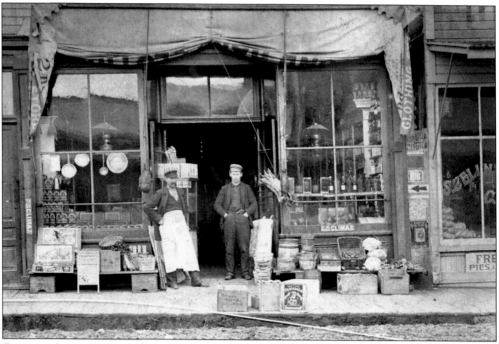

ZELINSKI GROCERY STORES. Jewish families joined other Americans on the trek west and became some of Old Tacoma's earliest settlers. Solomon and Amil Zelinsky were brothers who found their way to Old Tacoma in the 1880s. Both were grocers, with Sol establishing his store on the Old Town Dock and Amil locating on the west side of McCarver near North Thirtieth Street. With time, they combined resources and moved their grocery businesses to buildings at 2118 and 2120 North Thirtieth Street. In this photograph, unidentified members of the Zelinsky family stand in front of Amil's store. Sol's shop is partially visible on the right. By 1916, Amil had acquired Sol's property and constructed a two-story building on the site. From that time into the 1920s, motion pictures were shown here at "my favorite theater." The building is now an apartment house.

ASHER GIRLS. In this photograph, Jennie (on the left) and Henrietta Asher pose for the camera. Henrietta married Sol Zelinsky and joined him in the grocery business. The Tacoma city directories list her as the proprietor of the grocery shop located at 2116 North Thirtieth Street between 1907 and 1911.

WOLFF GIRLS. The Wolff family lived next door to the Amil Zelinsky house, located at 2115 North Twenty-eighth Street. It was therefore probably no accident that Adeline, pictured at left, married Amil. Fannie and Paula, on the right, are the remaining sisters in the portrait. Paula married J. B. Mamlock.

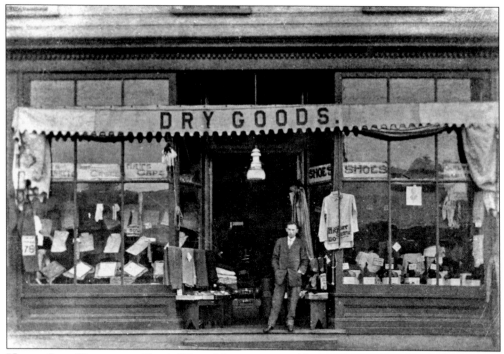

HARRY LEVI DRYGOODS. Harris "Harry" Levi is pictured here in front of his dry goods store. He arrived in Old Tacoma around 1912 and acquired the storefront at 2116 North Thirtieth Street for his business. This photograph was probably taken close to that time. By 1916, Levi was selling "men's furnishings," a business that continued into the 1920s.

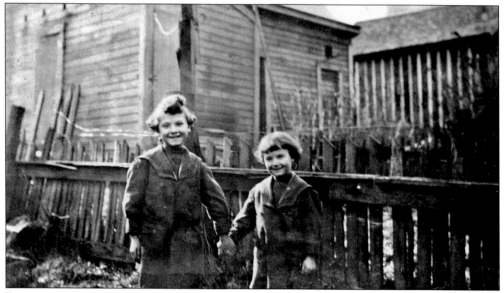

ROBERT AND CLYDE LEVI. Harry and his wife had the two boys, pictured here. When interviewed, Levi recounted his only experience with ethnic discrimination in Old Tacoma. It happened when one of his boys wanted to take piano lessons and the only available teacher was one of the Dominican nuns at Aquinas. Local Croatian Catholic boys taunted the young Jewish boy as he walked up the McCarver Street hill to his lessons.

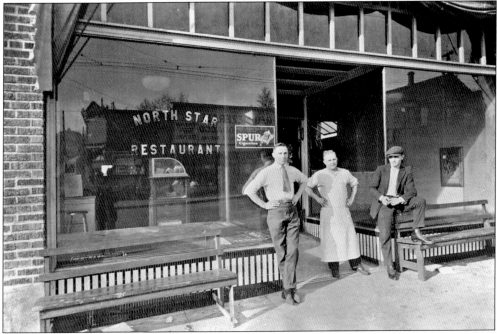

NORTH STAR RESTAURANT. Scandinavians shared the North Thirtieth Street business district with those of the Jewish faith and the Croatians. Here the proprietor of the North Star Restaurant Ole Nerheim (at left, wearing tie) poses with ? Strom (middle), and unidentified. The Radonich brothers had their billiard hall and Spar Tavern next door.

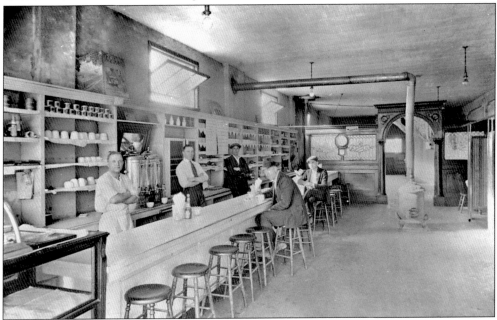

INSIDE NORTH STAR RESTAURANT. This photograph of the North Star offers a rare glimpse inside an early Old Tacoma restaurant. Ole Nerheim (wearing tie) stands behind the counter while Nick Mullan sits on the stool, closest to the photographer, drinking coffee. Only a potbelly stove provides heat.

IVER BELSVIG CASH GROCER. Iver Belsvig was introduced in the previous chapter to show that his business was a part of the North Thirtieth Street commercial landscape. He is pictured here in front of his grocery, and the image points to his Scandinavian origins. Although significantly altered, the store still stands. Iver and his wife, Amelia, lived at 1101 North E Street in a house that still stands.

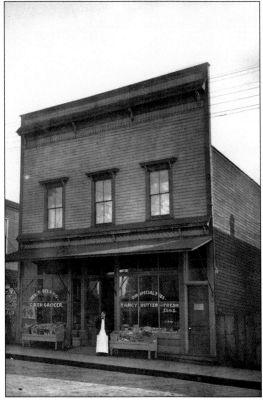

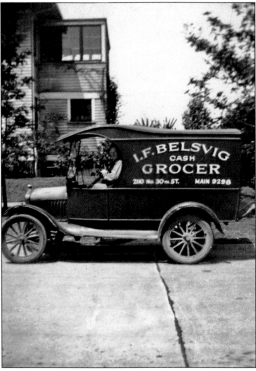

BELSVIG DELIVERY TRUCK. One reason for Iver Belsvig's longevity in the highly competitive grocery business was that he offered home delivery. He began the service early, when horses were the primary means of transportation. He then graduated to this delivery truck, one that allowed him to expand his business into Tacoma's North End.

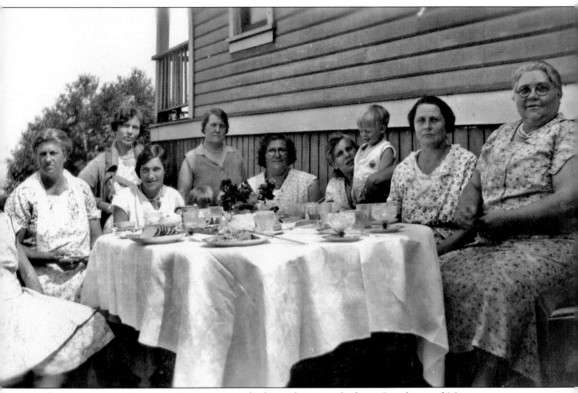

SCANDINAVIAN LADIES. Census records show that people from Sweden and Norway were one of the largest groups of immigrants to the United States during the 19th century. Before the arrival of the Croatians, Scandinavians were the dominant group in the neighborhood, and the men became commercial fishermen, longshoremen, or businessmen. In this photograph, some of the Scandinavian mothers, daughters, and wives of the neighborhood pose following an afternoon of tea and sweets. Pictured, from left to right, are Mrs. Olaf Wick, Martha Williamson, Anna Swanson, Anna Strom, Mrs. Isakson, Sara Wick, Mrs. Troseth, Mrs. Williamson, and Mrs. Fred Sealander.

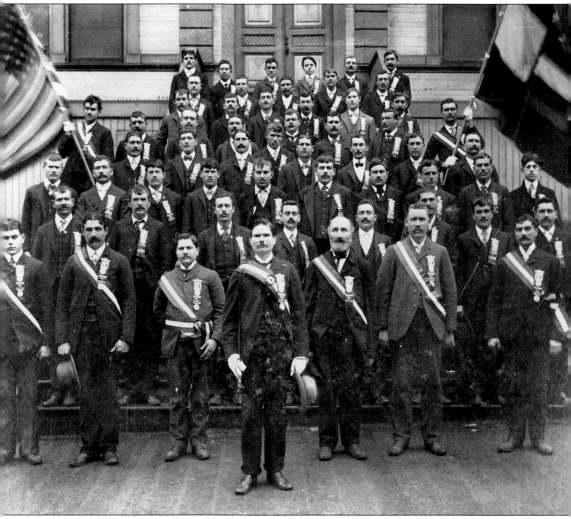

Austrian Benevolent Society Lodge No. 1. When Croatians first immigrated to the United States, the ethnic province was a part of the Austrian Empire. Immigrants left their native villages for various reasons: avoiding military service for a foreign empire, freedom from authoritarian rule, economic opportunity, and, most important, the ability to own land. Most ethnic populations organized benevolent societies to provide a needed safety net for its members. This image shows members of the Austrian Lodge, posed in front of their meeting hall located across the street from the present-day Slavonian Hall. Heading the group is Nick Blaskovich. In the first row, from left to right, are Frank Berry, Frank Tadich, Peter David, Andrew Martinolich, Dominick Constanti, and Spiro David.

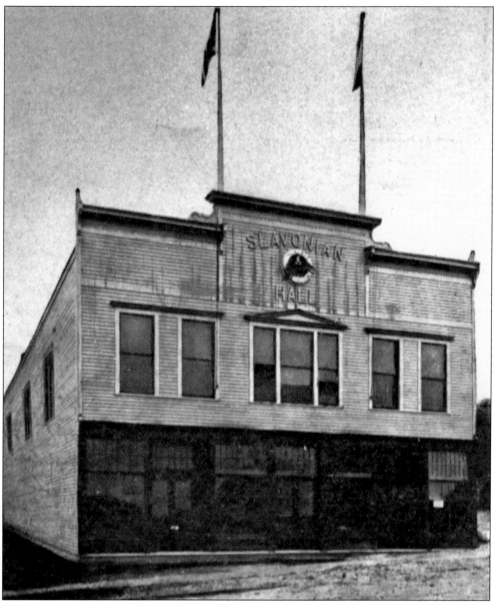

SLAVONIAN-AMERICAN BENEVOLENT SOCIETY HALL, 1907. The political situation in Austria, which ultimately led to the outbreak of World War I, affected the Croatians living in Old Tacoma at the time. If a young immigrant was sent to "Sera Kate's" boardinghouse, he was Croatian and supported the creation of a country independent from Austria. If, on the other hand, he went to "Sera Perina's," he was Austrian to the core. A split in the Austrian Benevolent Society occurred in the process, and on April 10, 1901, the Slavonian-American Benevolent Society was formed. The Slavonian Hall, located at 2306 North Thirtieth Street, was built six years later. The activities of the organization were social and financial and included health and dependency assistance, as well as a band and drill team that competed with other benevolent societies in Tacoma. The hall also was a place for entertainment, with a theater on the first floor where Serbo-Croatian language plays were performed. Prior to finding a home on North I Street, the Tacoma Little Theater also used the space.

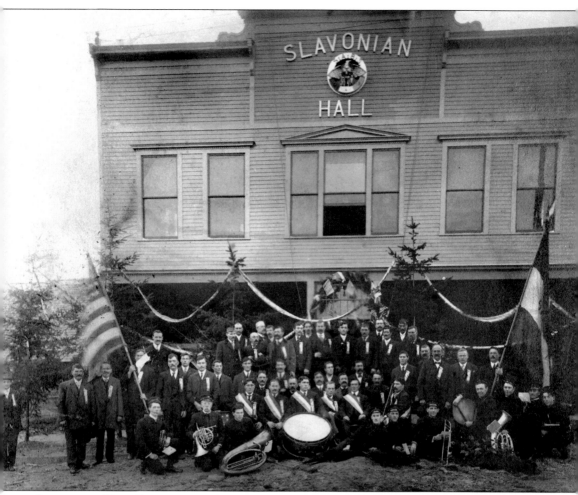

SLAVONIAN HALL DEDICATION. On January 6, 1907, as part of the Three Kings Celebration, Kelly's Band joined the dedication of the new Slavonian Hall. Posed around the bass drum are, left to right George Ursich (the first person wearing a sash), Vladimar Carevich, Lucas Labanco, Prosper Jurich (with drum on lap), Bepo Ursich, Martin Petrich, Anton Tarbushkovich, Andrew Gulich, Andrew Franetovich, and Shesha ?; and (gathered around the previous group) George Trudinich (holding the American flag), ? Stancich, Prosper Barcott, Nick Mullan, Steve Plancich, John Blaskovich, Andrew Berry, Nicola Fillippi, Steve Babare, John Depolo, Andrew Skansie, Anton Karabaich, Visco Kovachovich, Kovach, Tony Kuljis, Shima Milisich, Novak, Sam Kazulin (holding the Croatian flag), and George Bartich.

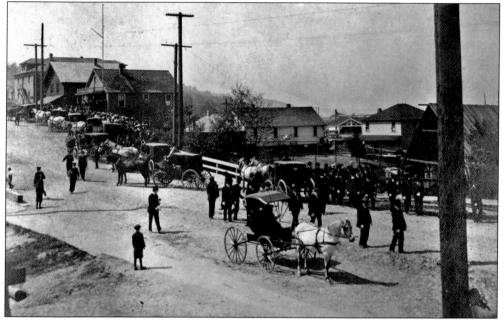

STEVEN BABARE FUNERAL. One of the responsibilities of the Slavonian Lodge was to make sure its members received proper funerals. This photograph shows the one given for Steven Babare, a boat builder who died in 1910. Lodge members are forming the procession that will head to downtown Tacoma, where all, including the remains of Steven Babare, will board a streetcar that will take them to the Catholic cemetery south of town.

FIRST BABARE HOUSE. George Babare (one of Steven's boatbuilder sons) and his wife, Mary, lived in this house located at 2513 North Thirty-first Street. The house was originally on North Thirty-second, near the Babare shipyards, but when the Northern Pacific extended its line through Old Tacoma c. 1914, it was moved uphill to North Thirty-first.

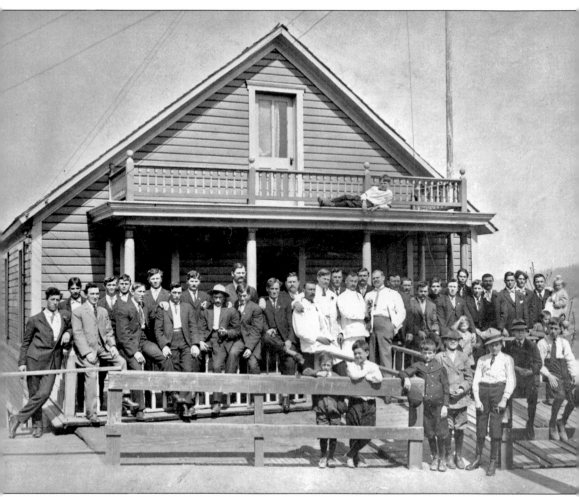

SERA KATE'S BOARDINGHOUSE. Boardinghouses in Old Tacoma were the first stop for the young unmarried Croatians and those supporting independence for the home country came to Sera Kate's. Katherine was married to Martin Berry and kept her boardinghouse on North Thirty-first Street. Pictured here are some of the boarders and neighbors. The boy stretched out on the second floor veranda is John Radonich. In the front row, the two young children are unidentified, but Joe Covach leans against the fence post next to them, while John Petrich leans against the other fence post. Sitting on the fence next to Petrich are Dinko Blaskovich and Paul Reed. Other identified men are Anton Bush, Nick Mardosich, George Trudnich, Andrew Kuljis, Jack Stanbuck, Vince Bartich, and Visco Lisisich.

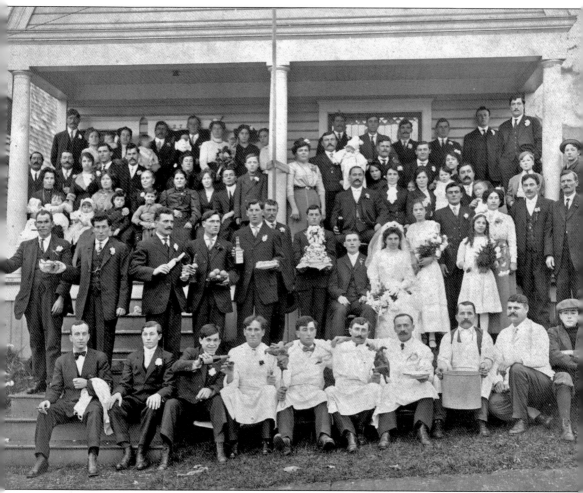

VITALICH WEDDING. Beyond events held at the Slavonian Hall, Croatians loved their weddings. Many a photograph has survived showing the attendees, complete with the wedding feast such as the wine, cake, and chicken seen here. Most of the people in this image came from the island of Brac. The celebration took place at the present-day Ursich house, located at 2721 North Starr. Included in this photograph are John Mardosich, Frank Cucilich, George Trudnich, Nick Rishich, Andrew Kuljis, John Passack, Vince Blagicich (?), Marci Broz, Andy Cucilich, Matt Vitalich, Steve Mariani, Nick Mardesich (holding the cake), groom John Vitalich, Lena (bride), Mary Kordich, John Zitkovich, Grace Sponorich, and Vince Plancich.

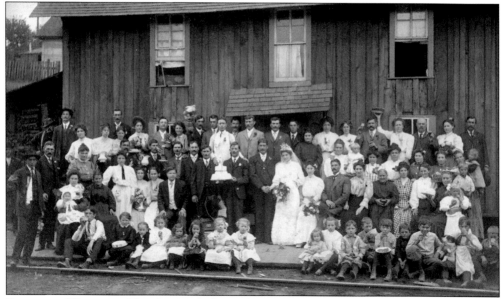

PLANCICH WEDDING. The first Nicholas and Perina Radonich boardinghouse, located close to where the McCarver Railroad Station later stood, was another favored location for wedding celebrations. In this 1907 photograph, bride Katie Radonich is shown with her new husband, Steve Plancich. To his right, Prosper Barcott holds the wedding cake. Tonina Barcott Petrich, to the left of the bride, was her matron of honor.

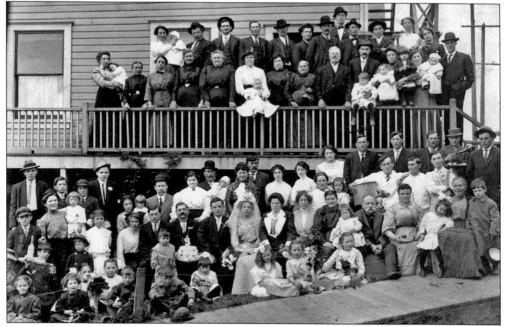

RADONICH WEDDING. By 1913, Radonich and his wife had constructed a new boardinghouse, complete with grocery store, at 2423 North Thirty-first Street. This wedding photograph depicts a newly married couple, Felia and Jack Radonich; Anton David holds the cake; Tonina Petrich (second to the bride's left) is once again the matron of honor; and Katerine Mardesich (center) and Tony Sutich (right) are the children posing on the upper railing.

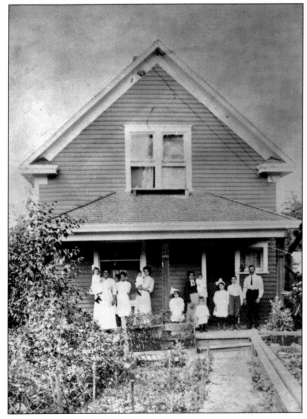

BLASKOVICH HOUSE. According to Mary Babare Love, this house was located on either Thirty-second or Thirty-third and North White Streets. Pictured here, from left to right, are Anton Buratovich, Pavy Buratovich, Jelica Mullan, Anna Blaskovich, Mary Berkovich, Frannira Rudan, Tony Rudan, and Lena Blaskovich; and the children at the top are Frank Berry, ? Berkovich, and Matt Berry.

SPONORICH HOUSE. Built in 1908, the Sponorich house still stands at the east end of North Twenty-eighth Street in Old Tacoma. Standing on the porch, from left to right, are Katherine Mardosich; her mother, Katherine; Grace Cammack; Anthony Milsoevich, Ellen Milsoevich; Lucy Sponorich; Antonia Sponorich; Emma (Sponorich) Sandstrom; George Sponorich; Anna Sponorich; Joe Sponorich; and John Sponorich.

VUKOVICH HOUSE. Located at 2805 (2809) North McCarver, this house was once home to fisherman Dominick and his wife, Marie Vukovich. Other Old Tacomans also lived here at one time or another, including physician William A. Monroe with his wife, Helene, and William L. McKenzie, whose transfer company was located near North Thirtieth and Carr Streets.

CROATIAN HOUSES ON NORTH STARR. In 1906, Samuel Andrews retained C. A. Darmer, one of Tacoma's early architects, to design these two houses on North Starr. By the time Andrews finished the project there were four houses that looked very similar, with each owned by Croatians who had close village ties to the Adriatic islands off the Dalmatian coast. Those living there included the Vladimer Carevich, Bepo Ursich, Nicholas Mullan, and the Kresimir Ursich families.

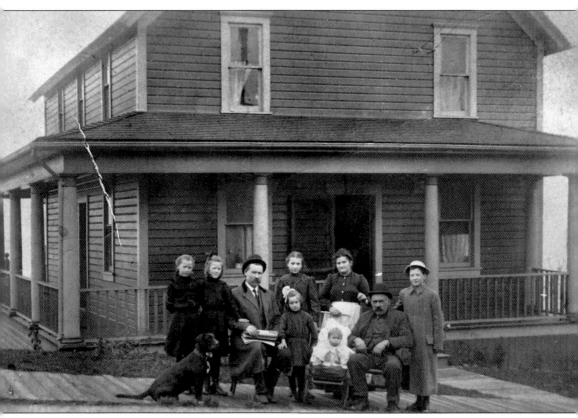

DOMINICK CONSTANTI HOUSE. In 1912, the Constanti's, along with some family friends, pose in front of the family home located at 2905 North Thirty-first Street. Pictured, from left to right, are Pearl, baby Marie, Luca La Banko, and Pete Constanti. Behind them are Winnie, Rachael, Dominick, Andrea, and Dominick's wife, Maria. When this photograph was taken, Dominick was proprietor of the Star Grocery at 2301 North Thirtieth Street. Maria was born to the Davids, another Croatian family in the neighborhood. In 1907, Peter David had a pool and billiards hall at 2119 North Thirtieth Street, while Spiro and his wife, Antonia David, operated the American Theater. John and Vinnie David lived on North Thirty-first Street in 1916.

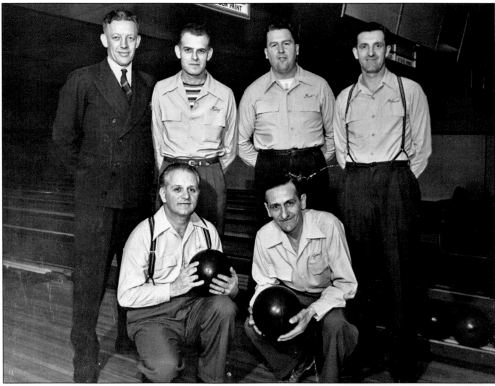

RADONICH BROTHERS. Bowling, as we know it today, was a natural outgrowth of bocce, an old country game played in both Italy and Croatia. Old Tacoma produced some champion bowlers who were initially reared on the ancient sport. John Radonich, kneeling on the left, and his brother Jim, on the right, were two of them. The most famous bowler, however, was Ted Tadich (not pictured here), who in 1938 bowled the first sanctioned 300 game in Tacoma's history.

GEORGE SPONORICH. In this photograph, George Sponorich, who grew up on North Twenty-eighth Street, is standing in front of Edward T. Eva's Old Town Pharmacy, located at 2202 North Thirtieth Street. George went on to sea and ultimately settled in California. Eva's drug store was also the Old Town post office until the station was closed.

JOHN TADICH. With his wife, Perina, commercial fisherman John Tadich lived on North Oakes. In addition, he was the union representative for the short-lived fisherman's union. In this role, he served as a link to local longshoremen unions so that fishermen, who worked primarily in the summer, would have winter employment.

BABARE SISTERS. Marie and Jennie Babare pose here on a snowy day on North Thirtieth Street, in front of the Pioneer Block and Rabasa's grocery store. The two were daughters of Old Tacoma boat builder George and Mary Babare. One of their neighbors was James Reid, a partner in the Crawford and Reid shipbuilding concern. Jennie coincidently married into the Reid family.

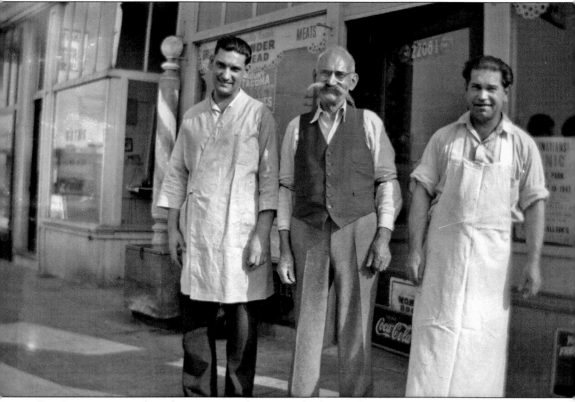

THE BILANKOS. Srecko Bilanco, pictured at center, had arrived in Tacoma from Croatia by 1910 and first spent six years working downtown at the Oyster House. Within a decade he is in Old Tacoma, going into partnership with Daniel Garbin by purchasing Amil Zelinsky's grocery store at 2120 North Thirtieth Street. Within three years, Garbin was gone and Srecko had moved to 2208 North Thirtieth Street, where he named his new store the Mount Tacoma Grocery and Meat Market. Here he maintained what some have called "the fisherman's grocery store," one where the commercial fishermen stocked their boats prior to leaving for the San Juans or Alaska. "Inside the store was a potbelly stove," reported Judith Kipp in the *News Tribune* in 1987, "Fishermen gathered on cold winter days to swap stories." Srecko, unlike most of the neighborhood, lived in South Tacoma, where he and his wife, Helen, produced two sons, Phil and Mitch, also pictured here. Phil, at left, ran the grocery (moved to 2210 North Thirtieth Street in 1954). Mitch ran the meat market.

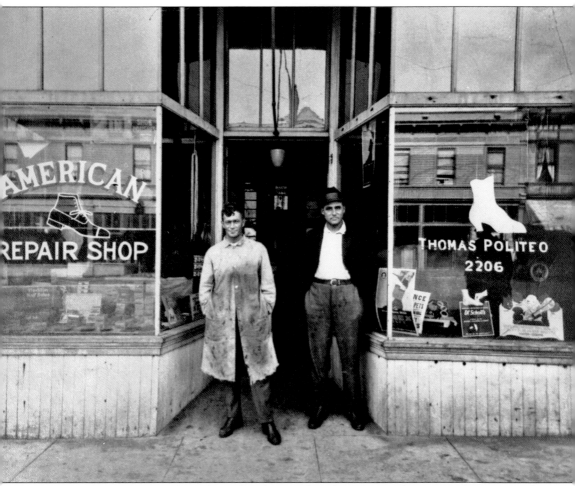

POLITEO SHOE STORE. Throughout this chapter there have been references to Croatians with Italian-sounding names. Constanti (sometimes spelled Costanti) and Babare have been two. Thomas Politeo is another. The northern reaches of the Slavonic provinces, in the old country, border on an area that was contested by both Austria and Italy. Intermarriage between Croatians and Italians was therefore inevitable. It is not known when the Politeo's emigrated from Croatia to Old Tacoma, but Thomas established this shoe repair business at 2206 North Thirtieth Street sometime in the 1920s. He was not the first to occupy the site. It was a popular location for barbers, with J. E. Hendrick one of the first. There was also a second storefront at the address where restaurants were a popular attraction, with Lucas Carich and R. Vrankovich being two of the restaurateurs. Most Old Tacoma residents remember this address as the site of the Galley West.

KIDS OF KUKLA TOWN. As small as the Old Tacoma community was, there were neighborhoods within the neighborhood. One was called "Kukla Town," so named after the Kuklan family, one of the areas first settlers. The neighborhood was hidden within a gulch where both North Junett and Thirty-third Streets end, and its isolation created an environment of nonconformity. Some of Old Tacoma's permanent residents grew up here, including Charles Marek, Adolph Cummings, Cecil Bloomquist, the Tadich brothers, and later the Sporich brothers. This c. 1912 photograph depicts some of the children of the neighborhood. Pictured, from left to right, are John Sisul, Andy Tadich, Hans Williamson, Jack Bailey, Cecil Bloomquist, and John Tadich.

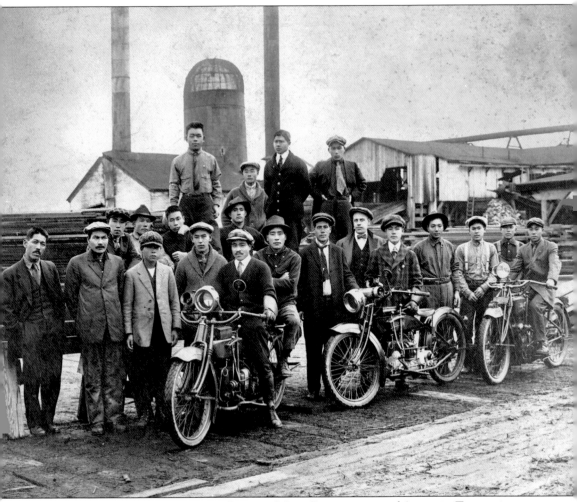

JAPANESE WORKERS AT DANAHER LUMBER MILL. Past treatment of Asians in Tacoma is not a pretty story. Chinese railroad workers and merchants were the first to arrive in 1873 when the Northern Pacific terminus arrived in Commencement Bay. Some lived in Old Tacoma, and a Chinese burial ground is mentioned in Tacoma City council minutes. In 1885, however, white workers—with the support of the local government—forcibly expelled the Chinese from both Old and New Tacoma. By the 20th century, Japanese families had settled throughout Pierce County, with many living in a neighborhood of their own in downtown Tacoma. However, the men in this photograph were not a direct part of this community. When labor protests led to strikes at the Danaher Lumber Mill after World War I, these Japanese workers were hired as strike breakers. They lived in a boardinghouse adjacent to the mill.

Four

ON THE WATERFRONT

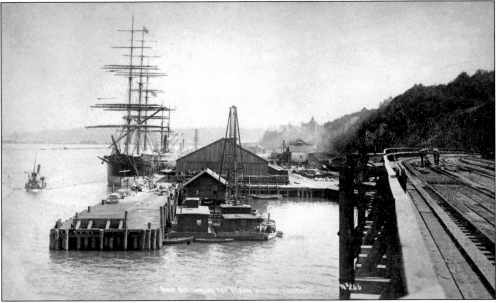

NORTHERN PACIFIC WHARF. This discussion of the Old Tacoma waterfront begins by looking south toward the Northern Pacific Railroad terminal wharves (downtown Tacoma is in the background). This part of the company's property sits adjacent to the coal bunkers, once located on the shoreline below present-day Stadium High School, about a mile from Old Tacoma. The image represents a part of Tacoma's first port, one restricted to the south shore of Commencement Bay until after World War I. The shoreline northward passed through Old Tacoma to Point Defiance and formed a second part of the port. Even though this entire development was linked by water, it was not originally connected by land. When the early minutes of the Tacoma City government are read, a failed attempt to construct a road between Old Tacoma and the Northern Pacific wharves is encountered. While the company eventually built the road, its refusal to allow the construction of a wagon road early on was one of the reasons why Old Tacoma remained isolated during the first years of its history.

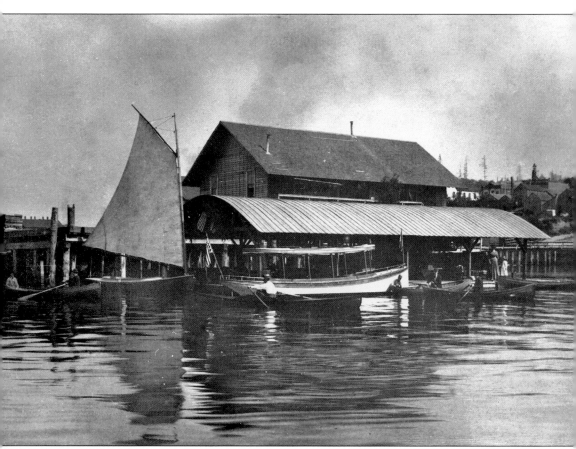

STEWART BOAT HOUSE. The shoreline area at the foot of North McCarver was awash with activity, unlike today. Collins and Sinsabaugh operated a produce store between 1889 and 1890. John and Charles Johnson had the grocery business on the dock in 1900, one ultimately taken over by Sol Zelinsky. On land nearby, one could find such businesses as machinists Oscar Blekum and Peter Petrich, many residential cabins, and at least one known houseboat occupied by laborers John Nelson and John Andrews. The Puget Sound Fish Company, owned by Peter Berry and John Budinich, was another feature of the dock. By 1890, boat builders became a part of the landscape, with Frank F. Wheeler one of the first to be recorded. Boathouses arrived by 1900, first under the management of Thomas G. Johnson. Pictured here is the boathouse when Milo E. Stewart owned it, around 1910.

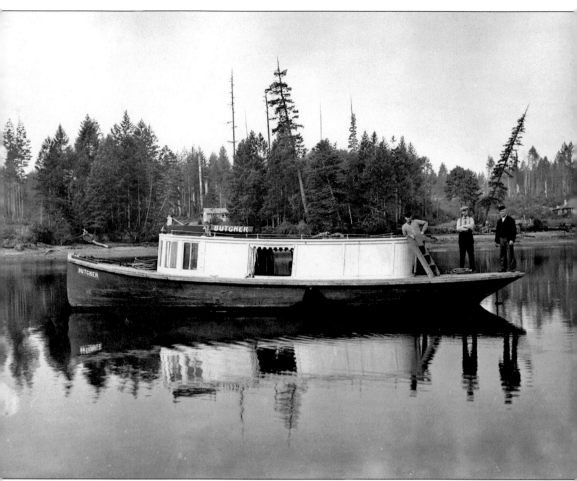

BUTCHER. In the early days, Old Tacoma had closer ties to the many other shoreline communities than it did to the city of Tacoma. Boats and passenger ferries, collectively known as the "Mosquito Fleet," were the preferred means of transportation, and many Sound residents found their way to Old Tacoma to do their shopping. Since these trips were only made periodically, grocery shopping was a problem. R. W. "Dick" Uhlman Sr., who owned a meat market in Old Tacoma, solved the problem in 1912 with *Butcher*, a 41-foot craft that took groceries to waterfront communities. One side of the boat had shelves for groceries and a counter was on the other side, with a chopping block for cutting meat to size. Uhlman had two routes that he rotated daily: Commencement Bay to Dash Point, and Burton and Dockton on Vashon Island. The service lasted until 1918, when Uhlman left Old Tacoma and settled his grocery business and meat market on land on Wollochet Bay.

RIGGS BROTHERS DOCK. Alternative commercial uses emerged along the shoreline as one by one the lumber mills closed. The Riggs brothers were both boat builders and ran a dock where, in 1939, the seiner *LaTouche* has stopped for fuel.

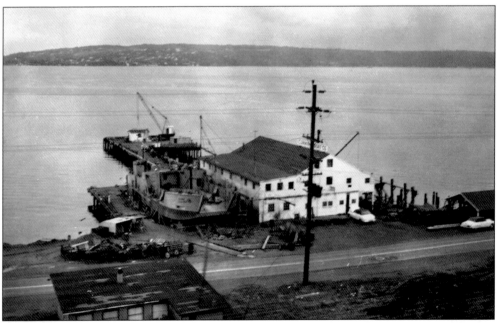

CUMMINGS DOCK. The Puget Sound Lumber Company sat on this Ruston Way site, near the foot of Cedar Street, from 1901 until fire destroyed it in 1930. The land then remained vacant until 1945, when Adolph Cummings bought the waterfront property in an estate sale and established a boat business on the western edge of the mill property. Cummings is credited with saving the Dickman head saw and carriage following the mill's 1979 fire.

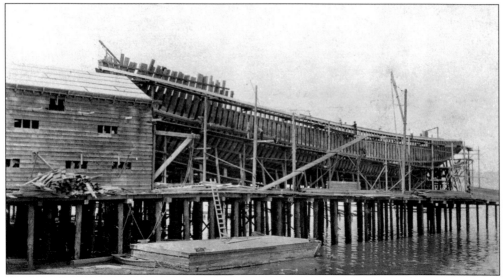

ELSIE OF OLD TOWN. Before and after America's entry into World War I, Nicolas and George Babare constructed vessels for the navy. This is the *Elsie*, under construction in 1916, a ferris ship the firm built at the time.

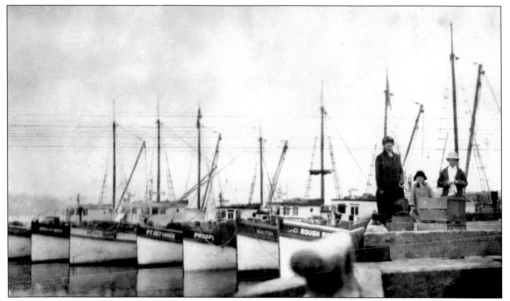

OLD TOWN DOCK, C. 1920. The City Wharf, its name at the time, continued to serve as the center of Old Tacoma's maritime activity into the 1920s. In this image, some of the local fishing boats are tied to the dock. Their names are (from left to right) the *Rough Rider, Rialton, Prosperity, Pt. Defiance,* the *Neah Bay,* and the *Oregon Wolf.*

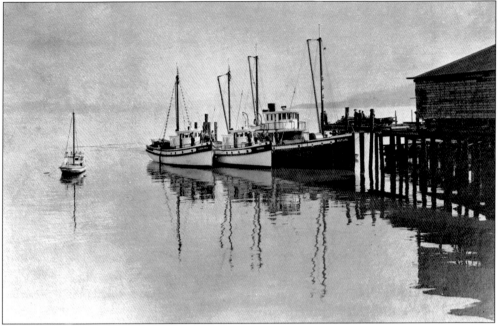

PETRICH DOCK. Other shipbuilding and boat docks shared the waterfront near the City Wharf. By 1916, the Petrich Dock was located in the vicinity of the one Lewis Starr constructed in the early 1870s. Petrich used a portion of the then abandoned Tacoma Mill Company dock to build his yard. Pictured here are the *Costa Rica, Georgia,* and the *Mutual.*

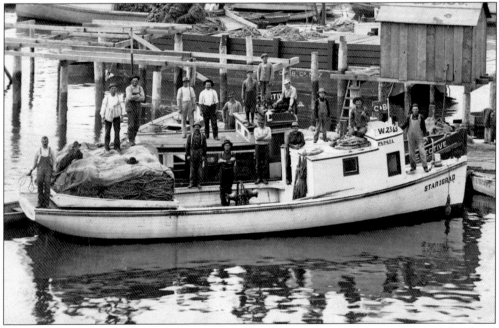

STARIGRAD. *Starigrad* means "old town" in Serbo-Croatian, so it seems appropriate that local fishermen would assign the name to one of their craft. Here it is tied up at Friday Harbor in the San Juans. Yearly, Old Tacoma fishermen would travel north to the islands in order to catch the migrating sockeye salmon.

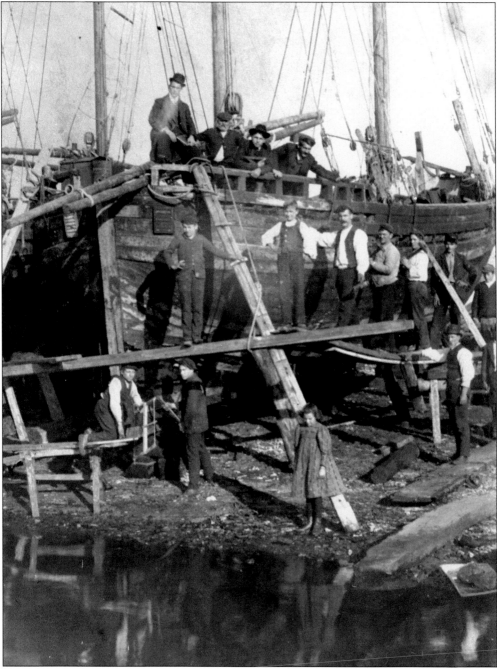

BOAT BUILDING IN CROATIA. The story of Croatian fishermen and boat building begins in the old country, as this photograph documents. Old Tacoma Croatians brought their boat building and fishing skills with them from Dalmatia and adapted the old ways to the new Puget Sound environment. In many instances, a fisherman would approach a local boat builder with a new design in mind, often with a modification of a previously built boat. With time, the end product of this collaboration between builder and fisherman was a purse seiner uniquely adapted to local waters.

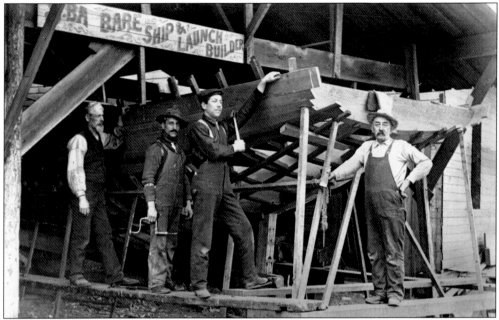

BABARE SHIP AND LAUNCH BUILDERS. Steven Babare began this shipbuilding concern, located at the foot of Carr Street, around the beginning of the 20th century. His two sons, George and Nicholas, established a second one next to their father's. When Steven died in 1910, the sons became sole proprietors of the entire complex. The company became one of the major builders in Old Tacoma, remaining at this location until the end of World War I. In this photograph, one of the Babare brothers, William Pohlman, unidentified, and Nicola Fillippi pose midway through the construction of a purse seiner.

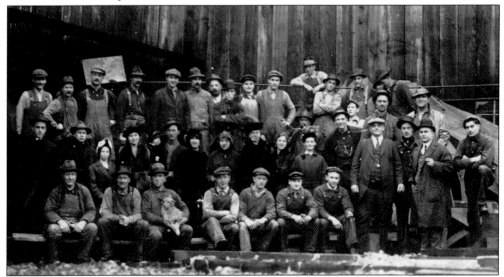

BABARE WORKERS. While the purpose of this photograph is unknown, a successful boat launching might be the reason. Workers are gathered around a finely dressed group of men, women, and children. And it is historically important to point to the dog posing patiently in the front row—the workhouse dog appears as a constant companion in many images of workers, be they ship builders or loggers in the woods.

BABARE BOAT UNDER CONSTRUCTION. Purse seiners were standard fare for the Babares, with Steven's 1904 *Sloya* one of the first built in Old Tacoma. During peak years they built at least 65, approximately one a week. But these boats were not the only vessels produced by the firm. During World War I, the federal government awarded the company a contract to build craft for the navy.

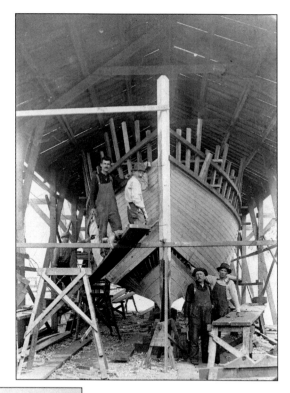

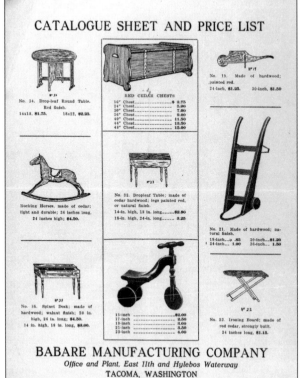

BABARE MANUFACTURING COMPANY. Following the brother's move to the Hylebos Waterway after World War I, construction diversified to include a wide array of household furnishings and toys, as this page from one of their catalogues demonstrates. A child's rocking horse could be purchased from $2 to $4. A strongly built red cedar ironing board cost $1.15.

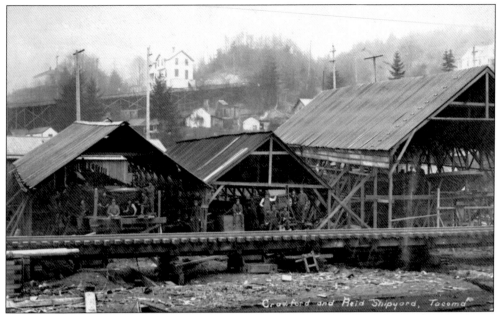

CRAWFORD AND REID BOAT BUILDERS. Crawford and Reid established this yard, located near the foot of Steele, around 1900. The photographer shows a unique feature of the yard as railroad tracks seen in the foreground separated the ships from the water. Therefore, every time there was a launching, workers would have to move the tracks to connect the ship to the waters of Puget Sound. The Reid house is in the background.

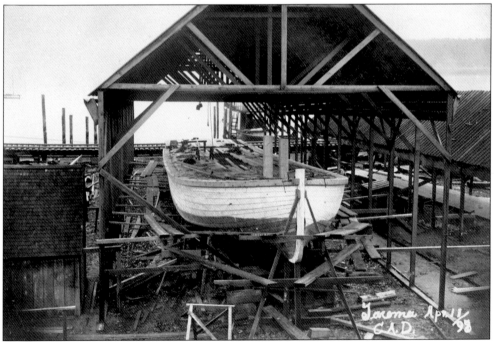

INSIDE CRAWFORD AND REID BOAT BUILDERS. In 1898, Tacoma architect C. A. Darmer, who later designed houses on North Starr, took this photograph of a Crawford and Reid boat under construction. This firm was known for their tugboats, with the *Elf* and *Echo* two of the most familiar.

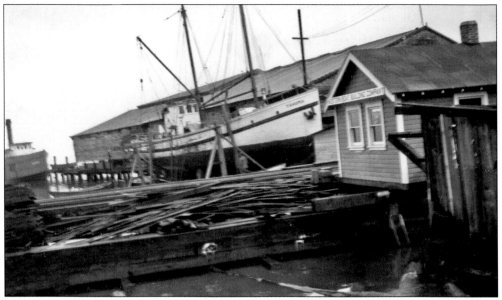

WESTERN BOAT BUILDING COMPANY. In 1916, Martin Petrich, Joe M. Martinac, and William Wicket started a boat-building yard on a portion of the abandoned Tacoma Mill Company site (now Hyde Park). Martin knew what a purse seine boat had to be by first fishing with his younger brother Jerry. Pictured here is his Old Tacoma boat yard before he moved the facility to a location below the Murray Morgan Bridge on the Thea Foss Waterway.

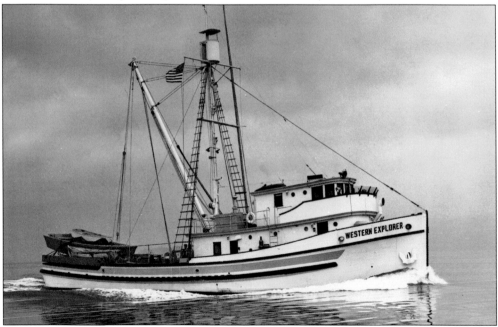

WESTERN EXPLORER. According to Hervey Petrich, one of Martin's sons who joined him in the business, the names of all purse seiners built by the company began with "Western." However, the *Western Explorer* was a little more unique than most of their boats. In the hopes of increasing sales, this one was to sail to the Atlantic Coast so as to demonstrate Puget Sound purse seine methods to New England fishermen.

MARTINAC SHIPBUILDING. Joe M. Martinac was born into a heritage of boat building on the Dalmatian coast of Croatia before immigrating to the Puget Sound region as a young craftsman. Before he started his own business in 1924, at the age of 29, he refined his skills working for the Skansies in Gig Harbor and the Babares in Old Tacoma, and had gone into temporary partnership with Martin Petrich (he is on the far right in the Babare workers' portrait on page 76). However, unlike Martin Petrich, who began building his own boats in Old Tacoma before moving to the Thea Foss, J. M. started on the waterway; but like the Petrich concern, Martinac descendants are still there. Pictured here are Joe M. and his son Joe S. Sr. Like all Croatian boat builders before them, the Martinacs were innovative, especially when taking the basic design for a salmon purse seiner and enlarging its size for tuna fishing.

EASTERN PACIFIC. Martinac christenings were grand affairs, and here the *Eastern Pacific* is ready for the event. Gifts were given to the new boat owner and a local priest blessed the undertaking. Photographs were taken of the bottle breaking and all watched breathlessly and then cheered as the new boat sled off the ways into the Thea Foss Waterway.

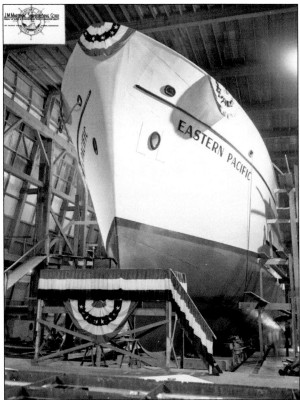

ROYAL PACIFIC. After the launching, the tuna seiner was outfitted for the voyage to fishing areas in the southern reaches of the Pacific Ocean. The mast was added, among other things, along with the power block. Then, as the *Royal Pacific* pictured here, the boat went through one final sea trial in Commencement Bay before heading to its new home.

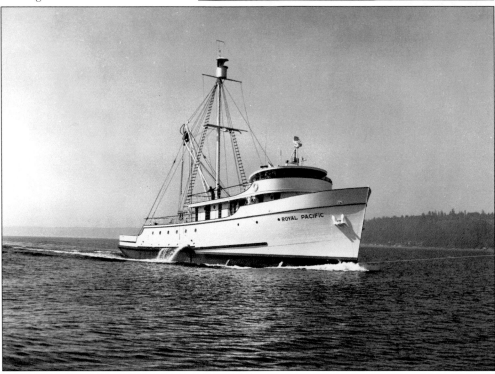

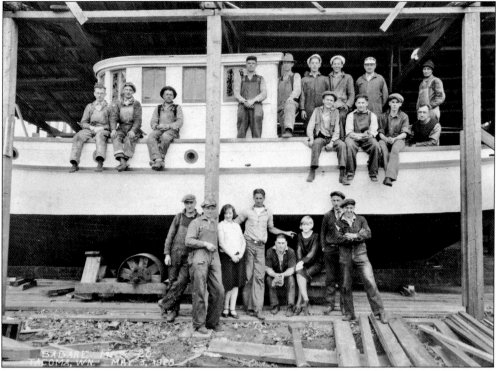

BOAT BUILDERS. The history of Old Tacoma boat building ends with a reminder about how important the industry was to local workers. This 1920s photograph of the Babare boat yard, after the company moved to the Hylebos Waterway, might show the future owners of the yacht *Arro* paying a visit.

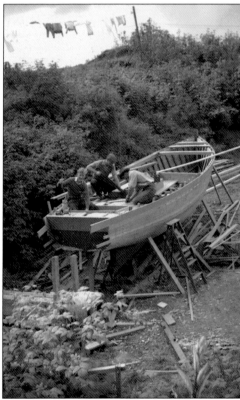

BACK YARD BOAT BUILDERS. When younger, Old Tacoman John Sponorich had a plan to build a boat and, along with his cat, have an adventure at sea. He and friend Ralph Carlsen (along with an unidentified third person) built the boat in a gulch located off North Thirty-first, in Carlsen's backyard. Unfortunately, the adventure was cut short when John fell asleep at sea and broke the boat on some California rocks.

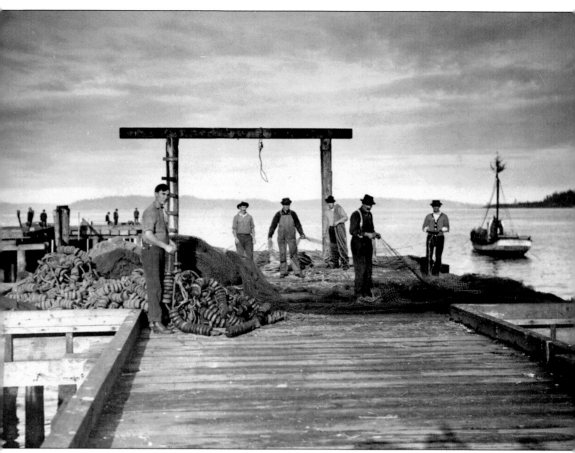

FISHERMEN ON OLD TOWN DOCK. Over time, it is noticeable that less commercial and maritime activity took place on the McCarver Street Dock, especially after Old Tacoma developed its own neighborhood business district and after the Northern Pacific Railroad reclaimed its right to the shoreline. Then, in 1913, a wood-plank elevated road was constructed, linking the shoreline via North Carr Street and bypassing McCarver altogether. The changes that left a vacant dock proved ideal for the Old Tacoma fishermen. Here they prepared their nets for loading onto their boats. From here, too, the fishermen could load provisions and other members of the crew living in Old Tacoma. Pictured, with a group of men, are Matt Vadonovich Sr. (standing next to the pile of nets) and Tony Cordich (center). The purse seine *Oregon* is visible in the water to the right.

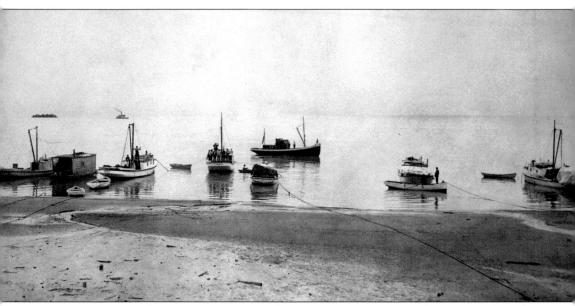

FISHING BOATS IN COMMENCEMENT BAY. There is a certain serenity in this photograph, unless the smells and sounds of the Old Tacoma shoreline are incorporated. To the left of the purse seiners, lumber mills stretch northward to Point Defiance. To the right is a mixture of lumber and flour mills leading southward to the Northern Pacific wharves and downtown Tacoma. The undeveloped clearing between the two industrial complexes became the first home for Old Tacoma's purse seine fishing fleet, manned by a combination of Scandinavian and Croatian fishermen. These men and their families joined the lumber and flour mill workers and longshoremen in forming a stable, self-contained, and oftentimes unconventional Old Tacoma neighborhood. World War II would destroy the closeness as men and women went off to war, and postwar development would begin to alter both the shoreline and Old Tacoma; but for at least a generation or so, the neighborhood was an ideal place to live.

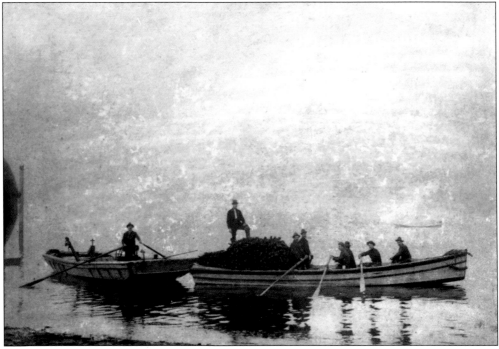

FISHING BEFORE STEAM. Pictured here is purse seine fishing when men provided the power using only oars. At left is an unidentified skiff man and at right is the unknown boat owner posed atop the fishing net. The oarsmen must also haul in the fish once a set has been completed.

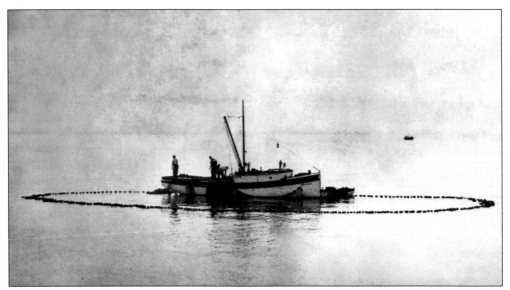

PURSE SEINER MAKING A HAUL. The goal with purse seining is to encircle the salmon using both boat and skiff, purse up the bottom of the net, and then haul the catch on board. This may be the *Urania* demonstrating a successful set.

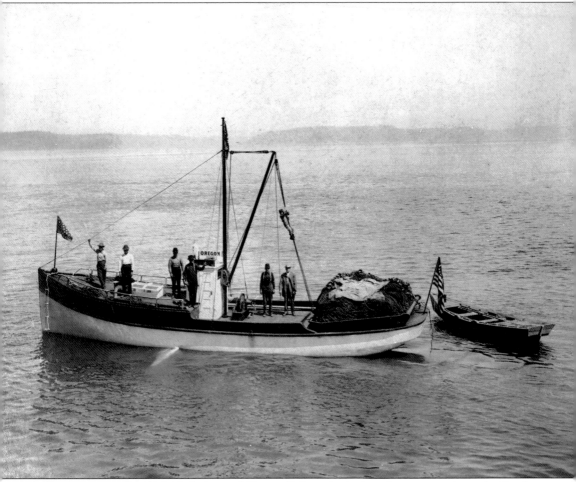

THE OREGON. In 1904, Nicholas and George Babare built their first purse seiner, the *Rustler*, for Frank Berry, six years before constructing this boat. Its owner christened his new boat the *Oregon*, an unlikely name for one destined to ply Puget Sound waters. Named after the battleship *Oregon*, the seiner was one of the first steam-powered vessels of its type and was made much larger than the older boats. It was, fishermen exclaimed in 1910, as "big as a battleship." Gradually, more and more of the seine operations were mechanized. Motorized skiffs came, along with the power block to haul in the nets, followed later by the motorized drum. Even with all of this mechanization, there was still one task that required human handiwork and skill—mending the nets. Pictured among the men are new owners Pete Milas and Tony Cordich (center) and Jerry Petrich (in the rigging).

LOOKING FOR JUMPERS. Fishermen will say that there was no leisure time on a boat as long as they could fish. These men are not, in other words, loafing. They are looking for jumpers, a sign that a school of salmon is near. The men will go into action with the first one seen; some head for the skiff, while others will man the nets.

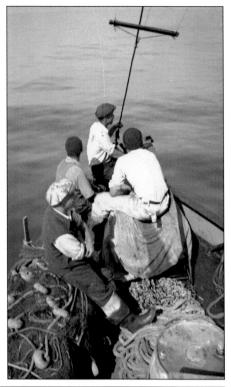

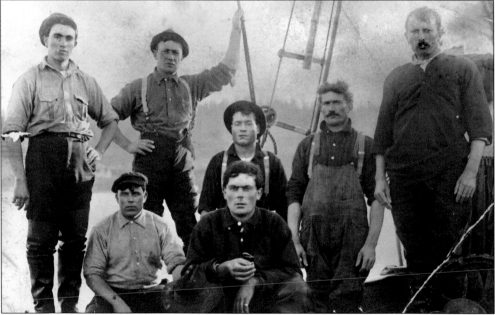

CROATIAN FISHERMEN. "No set of peoples are apparently more contented with their lot in life," reported the *Tacoma Daily News* in 1904, "as these Slavonian fishermen. In the early hours of the morning when the 'clonk-clonk' of their oars in the . . . boat catches the ear and the crews start for the scene of the days work, their voices can be heard—harmonious and clear—as they sing their native songs to the tune of their moving paddle."

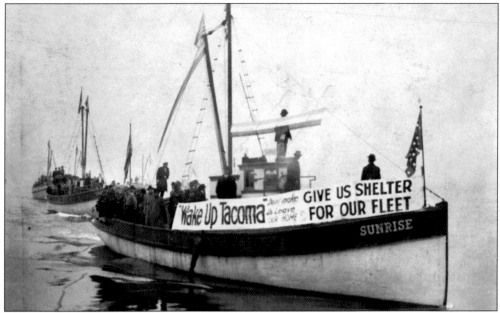

GIVE US SHELTER FOR OUR FLEET. "Wake Up Tacoma," the rest of the sign says, "Don't Make Us Leave Our Home." Home was Old Tacoma, where north winds hitting the south shore of Commencement Bay proved dangerous. Fishermen were protesting in 1912 because they wanted a protective breakwater. They were still waiting six years later when Peter David convinced the Tacoma City Council to appropriate $15,000 for a development that was never built.

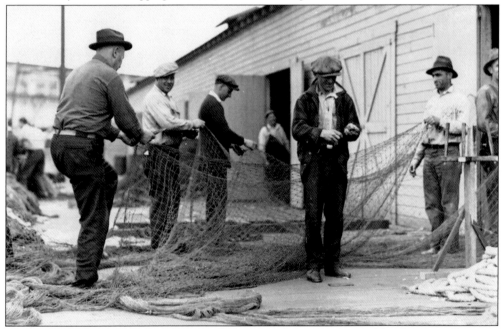

MENDING NETS AT PORT OF TACOMA. Shelter was ultimately provided by the Port of Tacoma once development got underway following World War I. Here, the Old Tacoma purse seiners tied up during the off-season and repaired their nets once it was time to head for the waters again. The only identifiable man is Tonsi Mladino, mending nets on the left.

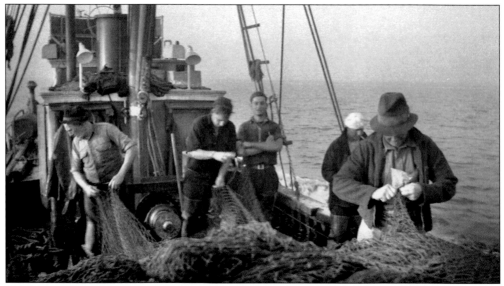

ON BOARD NET MENDING. Before net sheds were made available at the Port of Tacoma, fishermen readied their nets on available land in Old Tacoma. But there never was a guarantee that they would hold up through an entire season, especially for a fisherman unlucky enough to snag his net on the rocks. Therefore, the nets had to be continually inspected and repaired to make sure that not a single salmon went uncaught. Unknown fishermen are doing the duty on the *LaTouche* in 1939 while Frank Marinkovich Sr. looks on.

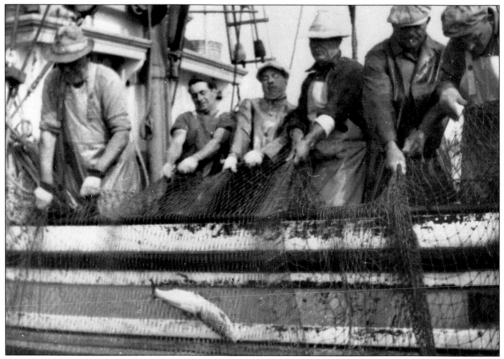

HAULING IN CATCH. Even though mechanized power blocks and drums eased the physical labor required to haul the salmon on board, this photograph shows that additional strength was required when brailing a bountiful catch.

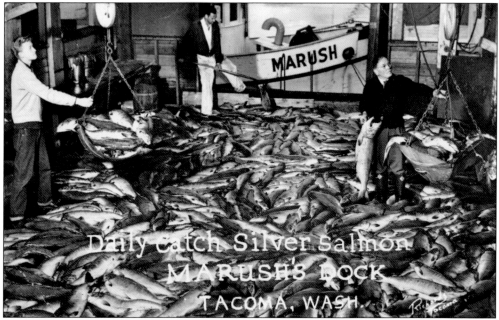

DAILY CATCH AT MARUSH DOCK. Croatian Old Towners who did not catch the salmon sold them in local markets. Mike Marush lived at the top of the Thirtieth Street hill and sold fish at his market, located below the Murray Morgan Bridge on the Thea Foss Waterway.

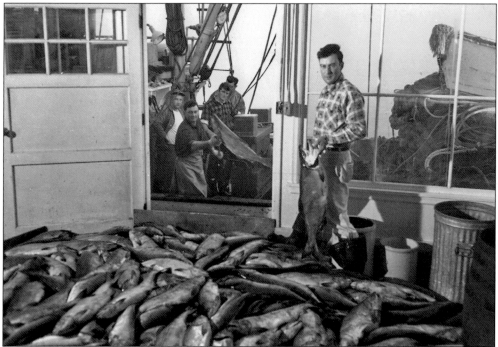

DELIVERING FISH TO OLD TACOMA FISH MARKET. The Old Tacoma Fish Market (now Johnny's) has been a fixture at the foot of McCarver for over 60 years. Here, in 1951, Frank Marinkovich unloads a catch of wall-to-wall salmon from the *La Touche*. Behind him is Nick Beritich while John Karabaich surveys the haul from inside the market.

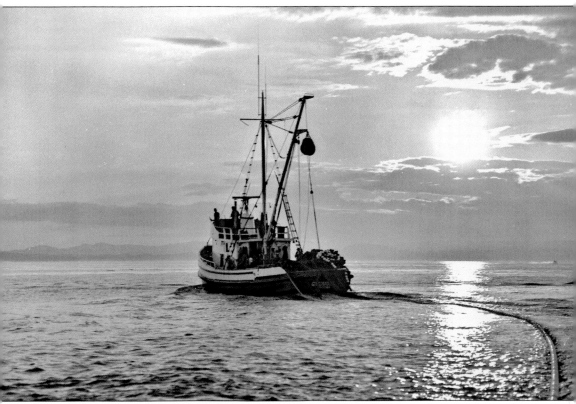

END OF AN ERA. Old-timers will say how Commencement Bay was so thick with salmon that a person could walk to Browns Point on their backs. From the very beginnings of Old Tacoma, fishermen made every effort to catch as many as possible. Frank Berry, for example, had a fish trap in Dumas Bay near Dash Point. When the State outlawed the traps as too devastating to salmon in the 1930s, the purse seiner became the most efficient vessel for the harvest. With so many seiners, soon the salmon population dwindled. In 1974, federal judge George Boldt granted Indian fishing rights in a decision that would have a major impact on the Old Tacoma fishermen. One by one, the older generation of Croatians sold their fishing licenses and purse seiners until only a few remained. Skiff man and photographer Ron Karabaich took this 1975 image of Frank Marinkovich's *Gladiator*, just as he and the seiner begin to make a set.

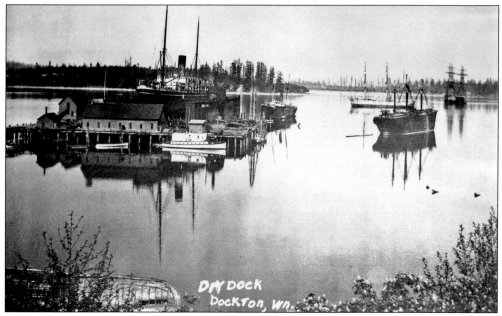

DOCKTON CONNECTION. As noted earlier, Old Tacoma was closely linked to other shoreline Puget Sound communities. This photograph, taken in 1893, documents one of them. Dockton was located off Quartermaster Harbor on Maury Island. Since space was limited along Commencement Bay, many maritime tasks were done here, including dry-docking of ships when maintenance was required.

SHIP DOCKTON, 1918. Boat building also took place on Vashon. Joe Martinolic Sr. had his yard here until he moved to the Tacoma port area and established his own company, where he added to the number of purse seiners plying Puget Sound waters.

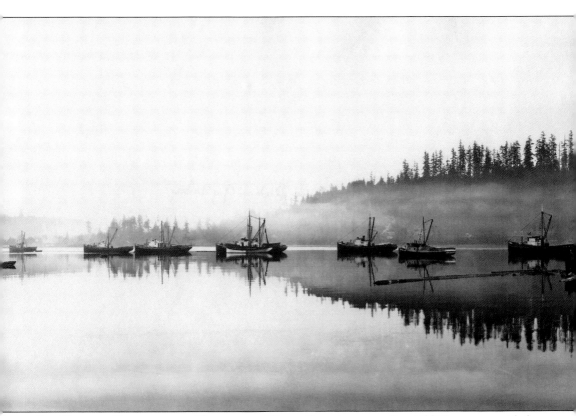

GIG HARBOR CONNECTION. The waters of Puget Sound surrounding Old Tacoma provided many opportunities for spawning beds, fishing fleets, purse seiners, and therefore Croatians. One such place was Gig Harbor, whose name, given during the 1841 Wilkes expedition, implied a safe haven for small boats. It was an ideal place for a fishing fleet, as this photograph shows. On paper, Gig Harbor, easily seen across the Narrows from Point Defiance and simple to get to by boat, is younger than Old Tacoma. Alfred Burnham did not plat the town until 1888, but Peter Skansie maintained that commercial fishing, and the Croatian connection, began in Gig Harbor in 1870, long before the Croatians arrived in Old Tacoma. By that year, Peter claimed, Sam Jersich, Peter Goldsmith, and John Fargo had already begun to purse seine in Puget Sound. Croatians then exported boat building to Old Tacoma.

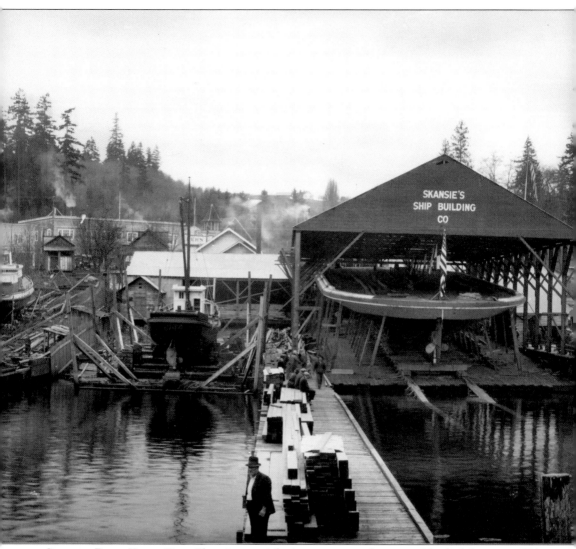

SKANSIE BOAT YARD. Peter Skansie was right in more ways than one. The link between Old Tacoma and Gig Harbor extended to commercial boat building as well. Peter, Andrew, Mitchell, and Joseph Skansie started as Gig Harbor boat builders in 1902, locating their business on the protected south shore of the harbor. Their output was substantial over the years, and ranged from purse seiners to automobile and passenger ferries that replaced the Mosquito Fleet. The Skansie boat yard was also the training ground for the Croatian boat builders who ultimately found their way to Old Tacoma, especially those who wanted to start businesses of their own. Martin Petrich and Joe M. Martinac were two of the known craftsmen who began as Skansie employees. There were undoubtedly others.

Five

LUMBER AND
FLOUR MILLS

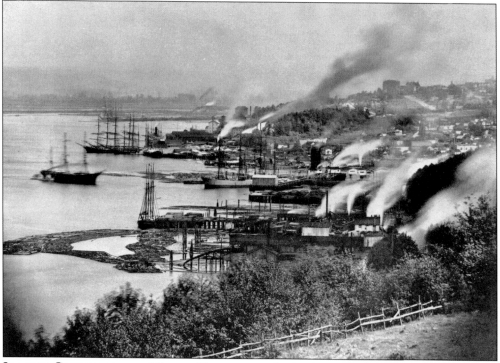

LUMBER CAPITAL OF THE WORLD. Tacoma was the lumber capital of the world when this photograph was taken in 1907. And the workers of Old Tacoma fueled the whole operation once logs arrived from the various Washington forests. Their tasks were many, beginning with the milling of cedar and fir into shingles, construction beams, or boards for home use or export. Machinists and crane operators were required, along with the lumber handlers and longshoremen who loaded ships. There were, at minimum, some 25 mills extending from Old Tacoma northward to the ASARCO smelter near Point Defiance. The golden age of timber, and Old Tacoma's role in manufacturing, lasted just over a century. Many reasons contributed to its decline, including a change in technologies and timber-management practices. For the companies along Commencement Bay, fire also added to economic change, leaving a shoreline that eventually experienced a rebirth as a public place.

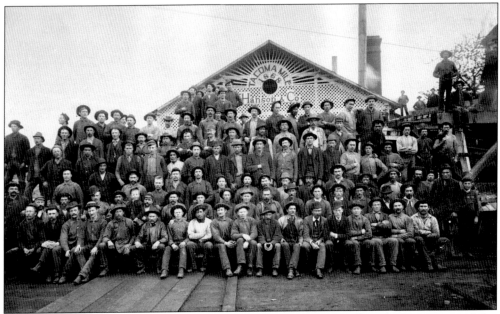

TACOMA MILL COMPANY CREW. When first introduced to this mill at the beginnings of this book, it was called the Hanson, Ackerson Mill, Tacoma's first producer of lumber, and one whose ownership base remained in San Francisco throughout its long history. A corporate restructuring in the 1880s led to the new name. Given the millions in board feet produced by the mill, its workers rarely had an opportunity to pose for a group portrait.

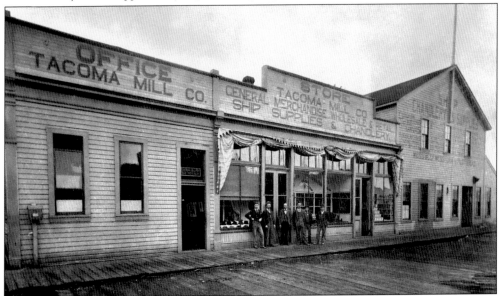

TACOMA MILL COMPANY STORE. The office and company store for the mill was an early and important fixture of the Old Tacoma landscape, especially before the neighborhood was able to provide basic services to its residents. While the gentlemen in this photograph are unidentified, they are undoubtedly part of either the mill or the store, one that sold everything from feed and seed to supplies for ships. It was also the local post office for a time in the 1880s. The store was located on the edge of Old Tacoma overlooking the mill.

SHERMAN WARD ON THE COMMODORE. The *Commodore* was a standard fixture along the Old Tacoma lumber docks during the peak of the industry. It continued to operate even after steam and more modern fuels replaced the older ships, sailing into the 1930s to become one of the last to carry lumber from the Old Tacoma mills. In this close-up, Old Tacoma longshoreman Sherman Ward poses on one of the four masts.

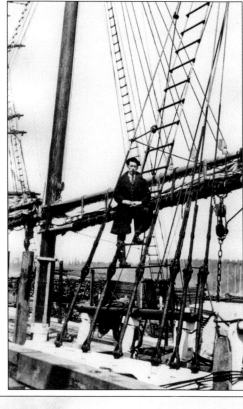

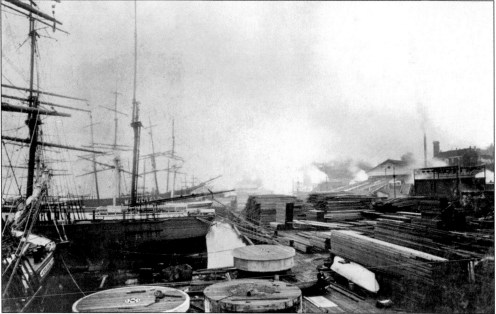

LUMBER WHARVES. This photograph provides a glimpse of the working environment of the mill workers and lumber handlers along the waterfront during the age of sail. A unique ship design was developed so that the milled timber was loaded through the stern, explaining why they are seen tied perpendicular to the Tacoma Mill dock.

BUILDING HENRY MILL. By around 1916, the Tacoma Mill Company ceased operations and a portion of the property had been acquired by W. Yale Henry and John C. Buchanan, who constructed a new mill on the site. This photograph shows the Tacoma Mill at the time of its demolition. The hill at left contains the remains of "Milltown," where workers once lived.

PEAK OPERATIONS AT HENRY MILL. Substantial changes occurred to the Old Tacoma shoreline by the time this photograph of the mill was taken prior to a major fire in 1942. Even though damaged at that time, the mill continued to produce pre-fabricated trusses during the remainder of World War II. It closed in 1950, and is now the site of the Dr. Jack Hyde Park.

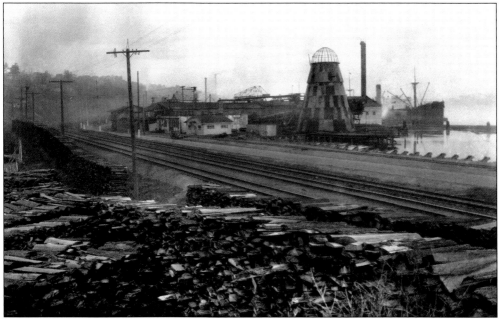

DANAHER/DICKMAN LUMBER COMPANY. There was a small mill on this site near the foot of Oakes as early as 1889, when Abraham Young established a shingle mill. Over time it grew and underwent various ownership changes before C. D. Danaher purchased it in 1916. Following his death in 1921, then mill manager Ralph Dickman Sr. purchased the plant. This image shows the mill in 1927 after Dickman purchased it.

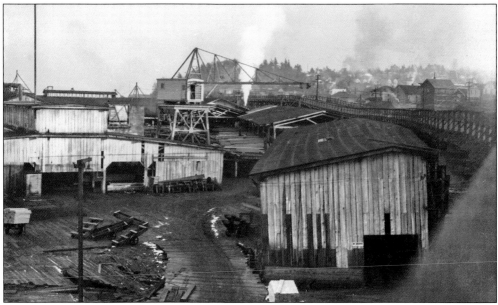

ELEVATED ROADWAY. Prior to his death, Danaher installed the electric crane seen in this photograph. Dickman modernized the plant by adding a second crane and an electric bandsaw. The elevated wood-plank roadway, seen on the right and constructed in 1913, led from North Carr (where it made a sharp turn, causing more than one automobile accident) and continued along Commencement Bay towards Point Defiance.

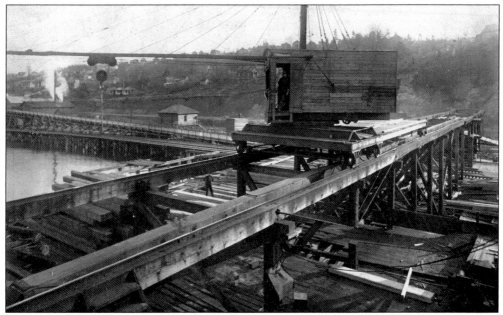

PUGET SOUND LUMBER COMPANY, 1901–1930. This mill, located between Junett and Cedar, remained a major competitor of the Danaher/Dickman concern until destroyed by fire in 1930. James Buchanan built it in 1901 and Edwin Wintermote became a partner in 1905. Seen here is the crane operator's view of the yard, taken around 1912, after a 1909 fire necessitated the reconstruction of the entire plant. Harry Gratton was the crane operator.

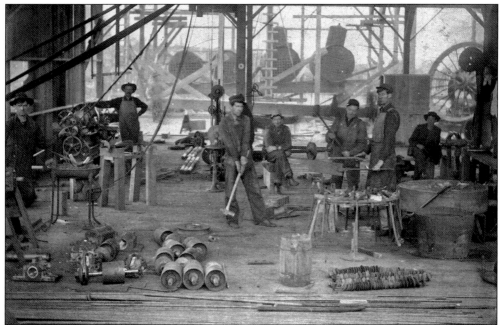

BOILER-MAKERS AT THE MILL. All the Old Tacoma lumber mills were continuously trying to keep up with changing technologies of the times. In this photograph, Puget Sound mill boilermakers are working on a changeover to steam, done probably after the 1909 fire. Two of the men pictured here are Ralph Ward and Harvey Oathout.

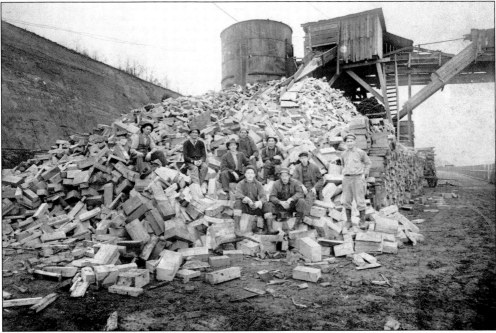

PUGET SOUND MILL WORKERS. Every lumber yard had leftover timber and sawdust. Much of it was consumed in the wigwam "hog" burners that lined the waterfront, a waste that also contributed to the air pollution that swept into Old Tacoma when north winds blew. Workers pose here on the milled ends left from the large timbers manufactured at the Puget Sound Mill.

PUGET SOUND MILL OFFICE. With windows looking out over the yard, the mill managers had a perfect opportunity to view the operations below. Note the handwritten ledgers and the old-fashioned telephone. The gentleman on the right is identified as a Mr. Knapp.

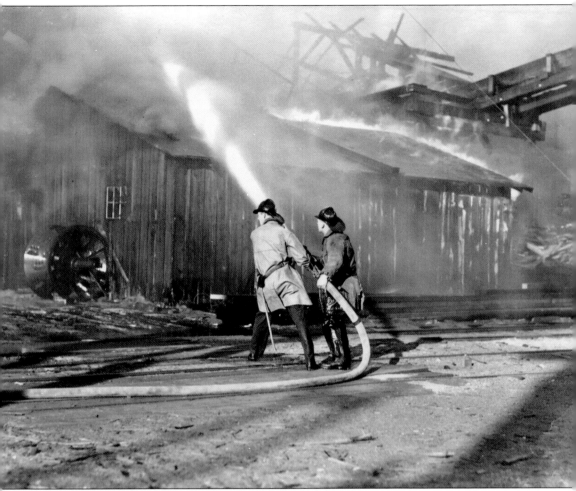

PUGET SOUND MILL FIRE, MAY 9, 1930. Fire plagued the entire lumber industry. In the Washington forests, natural and man-caused fires could destroy substantial stands of timber, and it was not until the 1930s, with the establishment of the Civilian Conservation Corps, that fire-fighting and prevention became a given in the woods. Fires in the mills along Commencement Bay were equally difficult to control, especially before the city acquired its first fireboat in 1929. The ability of mill operators to fight fire on their own could determine their survival. The North Shore Lumber Company, another Commencement Bay mill, was never rebuilt after a 1907 fire. Two years later, the Puget Sound Mill experienced its first fire, but James Buchanan was able to rebuild and continue operations until his death in 1928. Wintermote kept the mill operating until a second fire, pictured here, completely destroyed it in 1930.

COENEN-MENTZER LUMBER COMPANY. Today's Puget Gulch, near Alder Street, was a favored location for many of the early 20th-century lumber mills. Cyrus Mentzer and John Coenen built their lumber company within the gulch in 1901 and began production the following year. In 1905, however, the mill was sold to the Foster Lumber Company, whose owners changed the name to the North Shore Lumber Company. Two years later it was completely destroyed by fire.

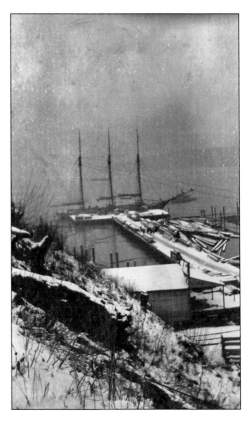

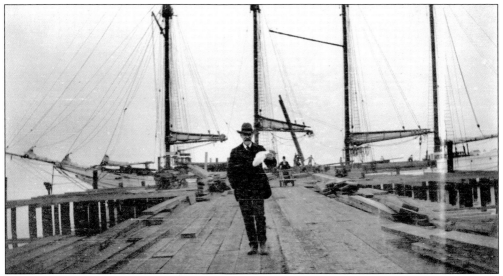

COENEN-MENTZER DOCK. This image, and the one above, shows the lumber company's dock reaching into Commencement Bay. According to Jan Nerheim, "Logs were fed under the railroad line . . . to a mill pond—it was a great distance," necessitating a substantial wharf structure. The name of the gentlemen in this photograph is unknown.

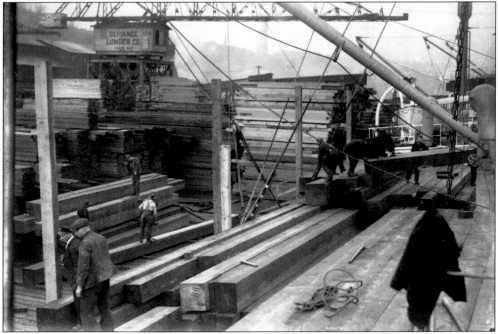

DEFIANCE LUMBER COMPANY, 1906–1951. With the financial assistance of lumber barons George Reed and John C. Buchanan, Doud brothers Leslie, Chester, and Willard began operating the Defiance Mill in 1906. Situated between Cheyenne and Mullan Streets, one of its distinct characteristics were two large cranes, one pictured here, needed to expedite the movement of milled timber in the yard. A lack of logs led to the mill's closure in 1951.

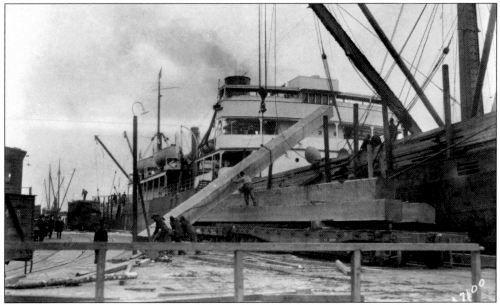

LOADING LUMBER AT DEFIANCE. During the peak of operations, especially the time between the two World Wars, the Defiance Mill exported its large timbers primarily to Japan, Germany, and Great Britain. This photograph shows the size of the timbers, called "Japanese squares," as they were loaded onto an unidentified steamer.

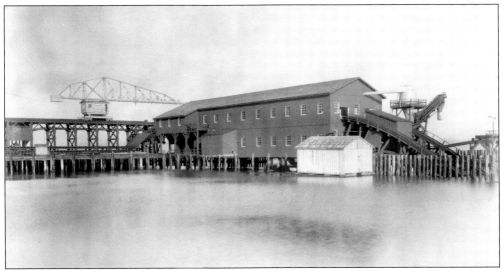

GANGE LUMBER COMPANY, 1930–1945. In 1929, Samuel Gange, who had formerly operated the Western Fir Mill, decided to build a modern, all-electric mill located on the present-day site of the Lobster Shop. Missing from this photograph of the mill is the "wigwam" burner associated with other mills along the shoreline. The company sold its sawdust locally as a heating fuel, so the burner was unnecessary. Samuel Gange died in 1951, six years after selling the mill to plywood manufacturer Donald Lyle, who closed it in 1945.

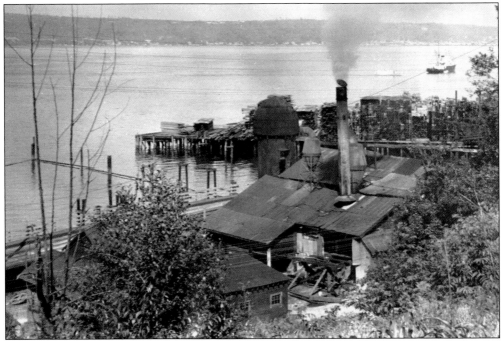

PACIFIC/LEYBOLD-SMITH SHINGLE COMPANY, 1903–1957. When this photograph of the mill was taken in 1956, it was one year away from its closure and demolition. Built as the Pacific Mill by Fred Johnson and the Hagberg brothers in 1903, and sold to Leybold and M. R. Smith in 1920, the mill was located near the foot of Pine Street and therefore close to the workers who lived in Old Tacoma. The Dickman Mill dock can be seen in the distance in this image.

105

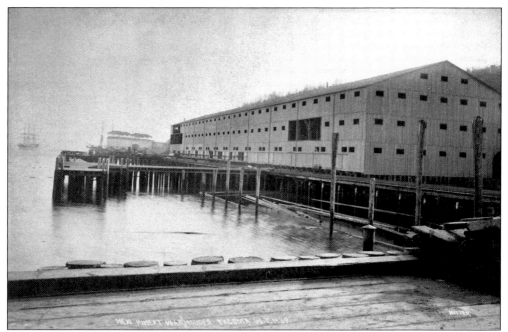

WHEAT WHARVES, 1889. The Commencement Bay shoreline south of the Tacoma Mill Company was an ideal location for wheat export wharves and flour mills, and while Thomas Rutter took this photograph in 1889, the building was probably built earlier as the first wheat warehouse in Tacoma. Its location is uncertain, but the background suggests that the building was close to the Northern Pacific coal bunkers, located below present-day Stadium High School.

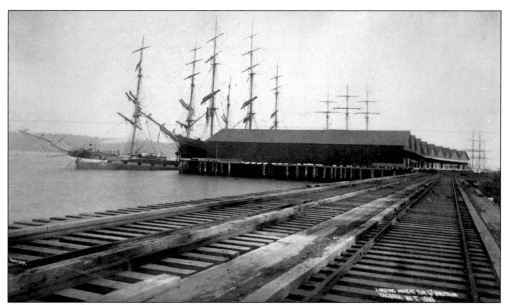

WHEAT WHARVES, 1888. Rutter photographed what was later called the Sperry Ocean dock in 1888. Before the production of flour at the site, the building was primarily a warehouse and the ships seen here are loading wheat headed for Great Britain. Although the building is gone, the dock remains and now naval supply ships are tied up to the facility.

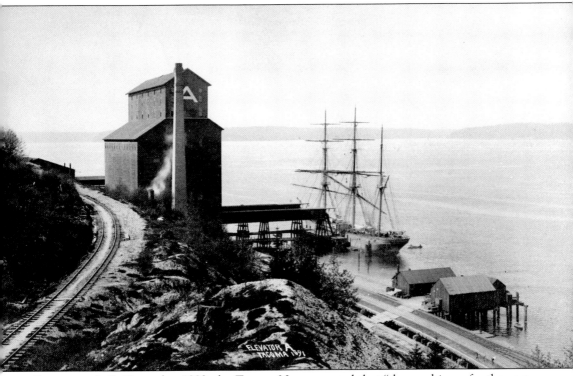

Elevator A. In December 1883, the *Tacoma News* reported that "the machinery for the new flour mill is expected to arrive soon." In July the following year, the paper commented that "from the large quantity of flour which passes through Tacoma for Sound points it would seem that a flour mill at this point ought to do a good business." Elevator A, constructed around 1889 by the Puget Sound Flouring Mill, was the end result. But it was only the first phase of a larger complex ultimately developed by the Sperry Company after it arrived in Tacoma in 1904 to build its own flour mill. By 1947, Sperry had acquired all the flour mills along the shoreline and in the process became a major employer of Old Tacoma workers. Millions of barrels of flour were exported yearly until 1965, when the mill closed because of the high cost of production. Within a decade, the entire complex had been demolished and Schuster Parkway had taken its place. Even so, ruins of the mills can still be seen when driving along the boulevard.

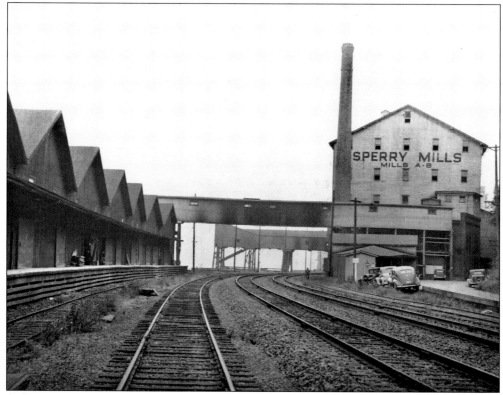

SPERRY MILLS. The mill specialized in a wide array of products under various names and for various uses. Rabbi Baruch Shapiro from Seattle, for example, would supervise the milling of kosher flour for the making of Passover matzos.

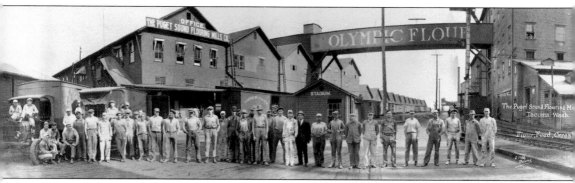

OLYMPIC FLOUR WORKERS. Newspaper accounts note that Sperry employed around 250 workers during the peak years of production. A few of them pose here between the mill and the shipping dock.

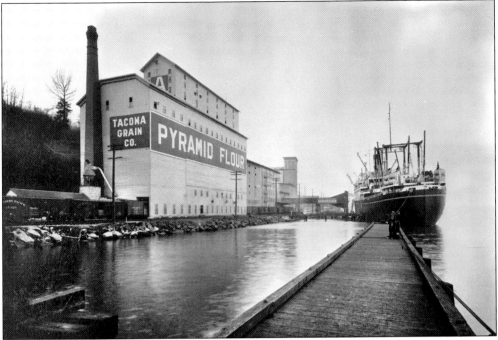

TACOMA GRAIN COMPANY. Pyramid flour was another product of the waterfront. While not pictured here, Sperry also sold animal feed. Approximately 75% of what was produced in the flour mills was exported.

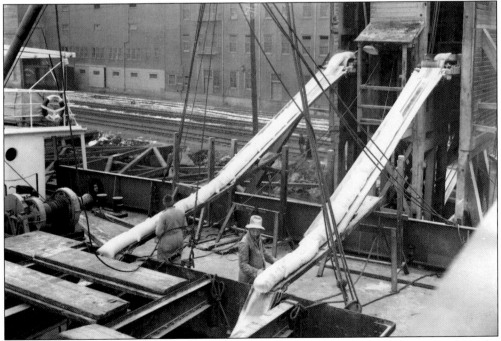

LOADING FLOUR AT TACOMA GRAIN COMPANY. Early reports of the mills' operation refer to the production of barrels of flour. Photographs of the interior of the Tacoma Grain Company show gunny sacks of flour. Pictured here are men loading loose flour into a ship's hold.

ELEVATOR A BEFORE SCHUSTER PARKWAY. One of the greatest challenges for motorists prior to the construction of Schuster Parkway in the late 1970s was the shoreline drive between Old and New Tacoma. Northern Pacific was resistant to construct even a pathway along this portion of the shoreline because it might interfere with its development plans. These included the 1914 rerouting of the main rail line so that it followed the Puget Sound shoreline, as well as also providing land for wheat wharves and flour mills. Eventually a road was built, but it proved to be a challenge, as many older drivers may remember. This image shows the one-lane road as it tunneled through Elevator A. A traffic light would tell the driver when it was safe to enter. And thus the road remained until the flour mills were demolished to make way for Schuster.

Six

CHANGE AND CONTINUITY

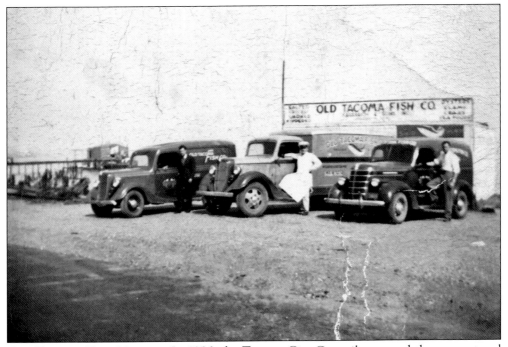

OLD TACOMA FISH MARKET. In 1986, the Tacoma City Council approved the concept and committed the funds to open the shoreline along Ruston Way to the public. By that time, all the major industries, along with most of the Old Tacoma workers who fueled them, were gone. And even before that year, the shoreline had begun a transformation less-industrial in nature. One example of this change occurred in the 1930s when the Old Tacoma Fish Company was built adjacent to the Old Town Dock. In 1935, Anton Karabaich Sr. bought the business. Anton had emigrated from the Island of Krk in the Adriatic in 1903 and originally sold fish door-to-door. He is pictured at center with sons John and Anton Jr. to his right and left respectively. Anton Sr. died in 1939, and when war came in 1941 the sons closed the market for the duration. In 1948, however, the brothers demolished the building seen here and Anton Jr., when he was not working at the Dickman Mill, and John built the market that one can still see today.

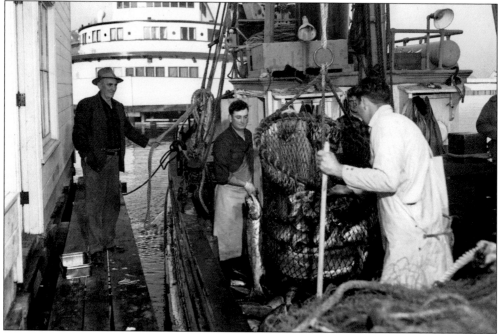

UNLOADING THE CATCH. In 1951, when fishing times were good, purse seiners would tie up and unload the catch at the Old Tacoma Fish Market. With Matt Vodonovich Sr. looking on, Frank Marinkovich and Matt Vodonovich Jr. unload a salmon catch from the *La Touche*. The Top of the Ocean is in the background.

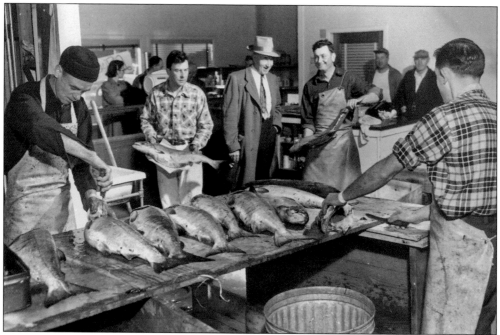

FISH MARKET INTERIOR. Inside the market, the fish are prepared for sale both to customers and to local restaurants. Anton Karabaich is filleting the fish on the left, brother John is to the right of him carrying a salmon, as is Frank Marinkovich. Steve Cvitovich has his back to the camera.

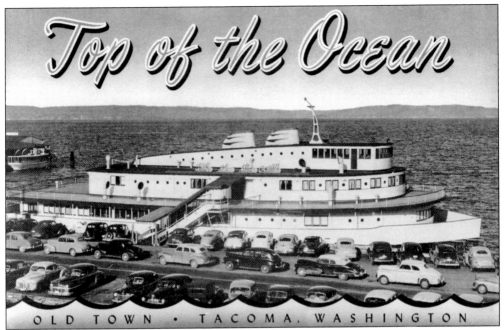

Top of the Ocean

OLD TOWN • TACOMA, WASHINGTON

TOP OF THE OCEAN. In 1946, architect C. A. Kenworthy designed this restaurant and dance hall resembling an ocean liner, located just west of the Old Tacoma Fish Market. Two years later, the Tacoma Athletic Commission acquired the property, managed the restaurant for the public, and had its offices upstairs, where ideas were launched for yearly water carnivals and Fourth of July celebrations. Proceeds from these events went to help local athletes.

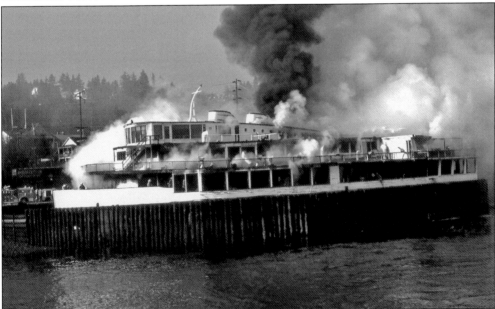

TOP OF THE OCEAN FIRE. In the early 1950s, the Tacoma Athletic Commission moved downtown, but the restaurant continued to operate until 1977 when it was destroyed by an arson fire. According to stories that followed the event, the arsonist wished to impress local Pierce County racketeers. He rode a taxi, carrying a can of gasoline, making his capture all the easier.

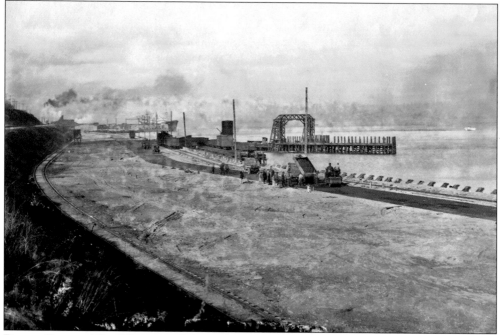

PAVING RUSTON WAY. The automobile revolutionized Old Tacoma and transformed the shoreline. At first, there was the elevated wood-plank roadway seen in photographs of the lumber mills. In 1925, city officials authorized the construction of a paved boulevard extending from North McCarver to the ASARCO smelter at Ruston. Significant progress is seen in this photograph, one that also shows the Milwaukee Road railcar ferry slip located east of the Defiance Mill.

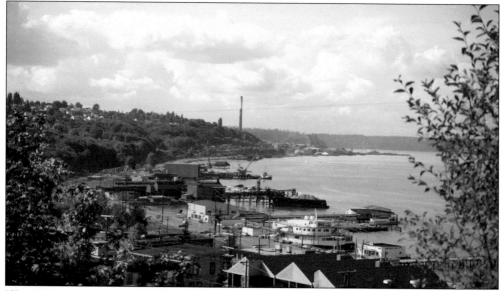

WATERFRONT VIEW, 1975. The Old Tacoma shoreline of the 1970s soon changed into the linear park and restaurants of today. The Top of the Ocean, the fish market, and Old Town dock are seen in the lower right in this photograph. The Dickman Lumber Mill that dominates the shoreline would close in 1977, followed in the 1980s by the ASARCO smelter, whose smokestack rises in the distance.

OLD TOWN DOCK TODAY. Tacomans now know the Old Town Dock as the focal point for major events. Fireworks are seen off it on the Fourth of July, and decorated boats and yachts pass by in spring and winter. On ordinary days people fish from the dock, and at special times the *Virginia V*—the last operating steamer of the original Mosquito Fleet—appears as she did while taking part in the Tall Ship parade in 2005.

DICKMAN PARK. When the Dickman Mill closed in 1977, the family sold the property to a private concern that had plans to create a commercial development on the site. A fire two years later, along with Old Tacoma neighborhood demands for a park and the preservation of the headsaw that survived the fire, led to the creation of this public place.

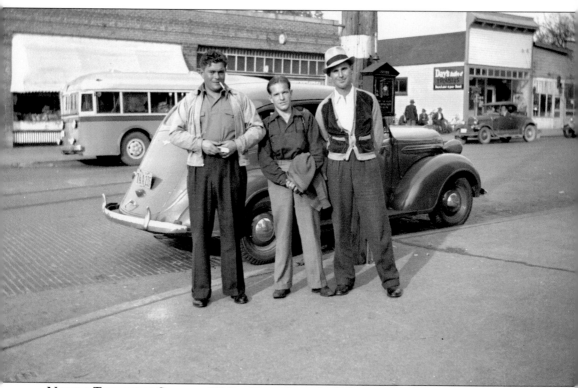

North Thirtieth Street, 1930s. Vince Borcich, "Chicago Pete" Pavecich, and George Cuculich (right) pose in front of a 1938 Plymouth parked on North Thirtieth Street in front of the Zelinsky Theater. By this time, the Old Tacoma business district had begun to shed its frontier appearance and was modernizing. The streetcars are gone—its last ride in Tacoma was in 1938—and buses now linked Old Tacoma to the rest of the city. Behind the boys, across the brick street, the David building represents the new Old Town. Parts of the original wood-frame buildings still remain next to the Spar, but their days are numbered. In a generation they would fall victim to a fire department that torched them to practice firefighting techniques. And so it was throughout the business district. The Pioneer block and Rabasa's grocery were razed by 1950. In 1957, the Tacoma Home Organ Society replaced a gas station that had earlier replaced the site of the jail.

ANTON JURUN ON NORTH THIRTIETH STREET. "Tonsi" Jurun, seen here walking past Bilanko's grocery around 1976, spent his working life at the Dickman Mill. In his younger years he was so strong that he could carry the big lumber beams on his back. Behind him is the Galley West restaurant, a favored watering hole for both neighborhood oldsters and youngsters.

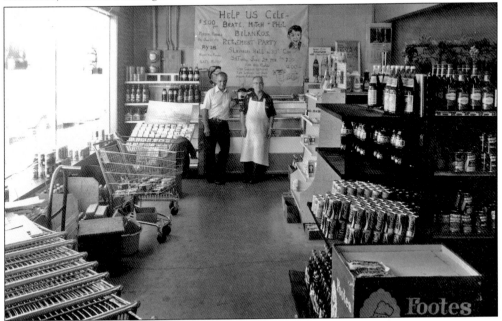

BILANKOS CLOSING. Phil (left) and Mitch Bilanko began working in their father's Mount Tacoma Grocery as youngsters delivering groceries. Ron Karabaich took this photograph of the brothers in their store in 1978, just before their retirement. With their departure, Old Tacoma lost two neighborhood characters and a business that had been in operation for over half a century.

OLD TACOMA'S BUS DRIVER. The Emerick family, which included Jane (widow of Peter) and sons Clive and Herbert, lived at 1116 North Twenty-sixth Street in Old Tacoma as early as 1910. This may be a portrait of Herbert standing next to his bus. He began as a streetcar conductor, so it seems a logical transition from the rails to a motor coach.

OLD TACOMA MAIL SERVICE. Even though Tacoma City had the first post office in 1869, the office was renamed Old Tacoma in 1884 and discontinued altogether three years later (Samuel C. Howes was the last postmaster). A postal station was then established at North Thirtieth and McCarver Streets in Eva's drug store. Eventually Old Tacoma had its own mailmen, including Dave Huber, pictured here.

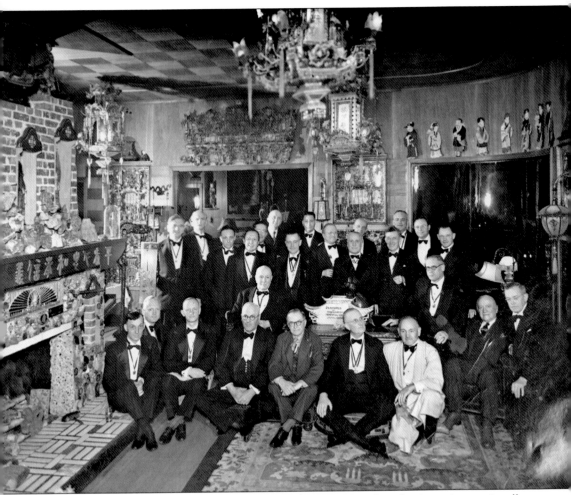

WALT SUTTER. Once at 2600 North Carr there was a house so marvelous that it was internationally known for its contents and landscaping. Walt Sutter was born in 1881 and spent 40 years at sea before settling in Old Tacoma. He purchased Fuller's Domestic Water Works and began a garden that ultimately included rocks from every state and territory in the nation, along with many from foreign countries. The interior furnishings of his house dazzled the public, for here he had on display artifacts he acquired in China at the time of the 1930s Japanese invasion. Sutter's story as to how he obtained them may or may not be true. While in China, he allegedly befriended Chinese president Chaing Kai-shek, who asked Sutter to hold art treasures removed from the Dragon Throne room in the Forbidden City in Peking for safekeeping. Pictured here are local Freemasons in his living room where the artifacts were on display. Sutter is the robed gentleman at the lower right. Thousands of people viewed the masterpieces, a parade that continued until Sutter's death in 1947.

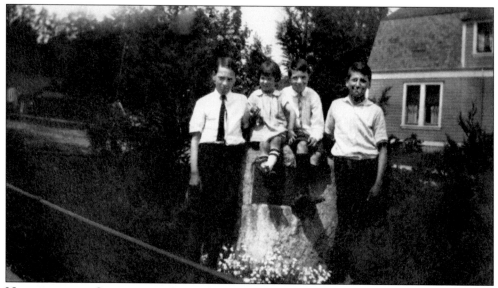

NEIGHBORHOOD CHILDREN ON STARR STREET. Hundreds of children have lived, gone to school, and played in Old Tacoma in the past, again pointing to the importance of families in the neighborhood. In this undated photograph, a few pose here at the corner of North Twenty-eighth and Starr Streets. Two youngsters sit atop the original marker commemorating the location of Tacoma City's first school.

NEIGHBORHOOD CHILDREN ON CARR STREET. Ron Karabaich, Patsy Cummings, and an unidentified boy (right) momentarily pause from their play in the early 1950s for this photograph. Behind them are buildings that were once the Star Grocery and Stambuck's saloon and pool hall. In 1957, the vacant land on the left would become the clubhouse for the Tacoma Mountaineers. Tacoma utilities would commandeer the land on the right for a substation.

LOWELL SCHOOL CLASS. This 1944 first-grade class posed on the entry steps of Lowell School, located up the hill from Old Tacoma on Thirteenth and North Yakima Streets. It was a grand edifice easily seen in some of the images in this book. Within four years of this photograph, however, the building—along with one of its students—fell victim to the 1949 earthquake, one of the worst in Tacoma's history.

LOWELL SCHOOL TODAY. During the earthquake, some children were standing just outside the stone building when debris began to fall. One of the students was just about to be hit with parts of the collapsing building when Marvin Klegman pushed him aside. Marvin was killed instead. This statue, dedicated in 2005 and located on North I Street near the "new" 1950 Lowell School, honors Marvin Klegman for his bravery.

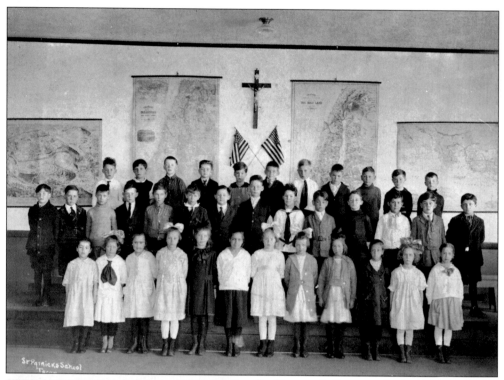

ST. PATRICK'S SCHOOL. In April 1920, Class 2 at St. Patrick's School posed for this class portrait. The names are not known, but the photograph illustrates the strong and close relationship between Old Tacoma Croatians and Roman Catholicism, a connection still present today.

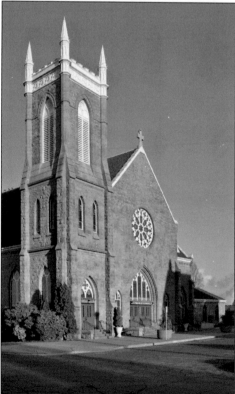

ST. PATRICK'S TODAY. There are two places where the lives of Old Tacoma Croatians are now commemorated. One is Calvary Cemetery at West Seventieth Street off Orchard in South Tacoma. Walking through this burial ground, names of hundreds of families who once lived in Old Tacoma can be found. The journey to their final home oftentimes began at this 1905 church overlooking the school that many attended and the neighborhood where they lived.

SANDLOT BASEBALL. Sandlot baseball continued to be a major sport of neighborhood children and remained so until the neighborhood had its own playground. In this 1926 photograph, young Kresh Ursich plays the fielder to runner John Sponorich. The two boys pictured lived close to each other at North Starr and Twenty-eighth Streets.

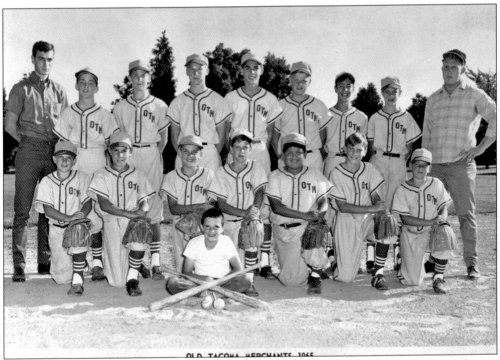

OLD TOWN MERCHANTS, 1965. By the 1960s, local merchants were sponsoring city-league softball teams. Pictured here, from left to right, are (first row) S. Burns, M. Babare, K. Todd, T. Karabaich, G. Landry, K. Marsh, R. Barns, and L. Todd (bat boy in front); and (top row) C. Pelzel, P. O'Rourke, G. Smith, D. Inman, G. Nysen, S. Marek, J. Catalinich, T. Tretton, and W. Ward.

CARR STREET, 1950S. This photograph looks west from a garden near the corner of North Twenty-ninth and Carr Streets sometime after 1957. On the right is the roof of the Tacoma Mountaineers, barely seen in front of the Slavonian Hall. One of the many McKenzie houses is on the left, occupied in 1920 by Henry McKenzie, president of Community Trucking Company. It was demolished in 1968 to make way for an apartment.

SPUNKY. Even though a part of the city, Old Tacoma has always had its fair share of critters, from raccoons, possums, and deer wandering from gulch to gulch, to foxes and a wayward peacock or two. Chickens were kept domestically into the 1970s, and George Canfield kept bees in his house on North Twenty-ninth Street. Tony Sponorich, pictured here, raised ducks in the gulch located next to his house at the east end of North Twenty-eighth Street.

BUNGALOW GROCERY. Tucked among the houses around 2110 North Twenty-seventh Street, the Bungalow Grocery remains one of Old Tacoma's hidden treasures. The early history of the building is unclear, but Henry Ramsdell lived here in 1900 and he might have built the store. It is known for sure, however, that Einar and Edith Larson owned the store in the 1930s, followed by the La Plantes of Salmon Beach.

SEAMEN'S REST. After the Funnemarks moved the Seamen's Rest downtown, longshoreman Jacob and his wife, Deanna (Dena) Quilhough, owned the house and remained there into the 1940s. City directories then show Hazel Wick Seaholm, and then Charles and Hazel Marek, owning the house from around 1947 until Hazel's death in 1994. Charles, who was an electrician by trade, died in 1971. This photograph of the Tacoma landmark was taken in 1990.

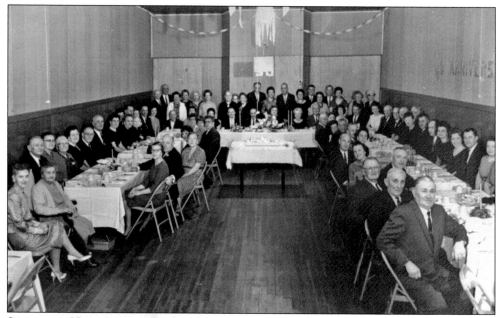

SLAVONIAN HALL EVENTS. For decades, the Slavonian-American Benevolent Society has hosted events for its members, with the Three Kings Dance the most noteworthy. In addition, yearly Daffodil Festival dinners, along with its use during the Old Town Blues Festival, extends the hospitality to the general public. The rooms were also ideal for small parties. In this undated photograph, friends and family of Dominick and Andrea Constanti gather to celebrate the couple's 50th wedding anniversary.

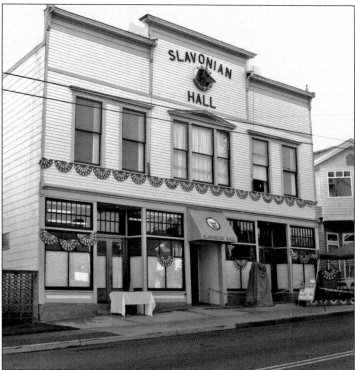

CELEBRATING A CENTENNIAL. In 2001, the Slavonian-American Benevolent Society celebrated 100 years of existence. During the century the building had become a national landmark and the organization had received a grant to restore it. Here, it is ready for the celebration, one that included the unveiling of a statue commemorating the Old Tacoma Croatian fishermen.

OLD TACOMA, 1982. Both old and new are present in this photograph taken from Prospect Hill. Seamen's Rest can still be seen in the lower left, along with the house once lived in by Edward Eva, proprietor of the Old Town Pharmacy. At upper right, new condominiums and office buildings serve as a backdrop to St. Peter's church.

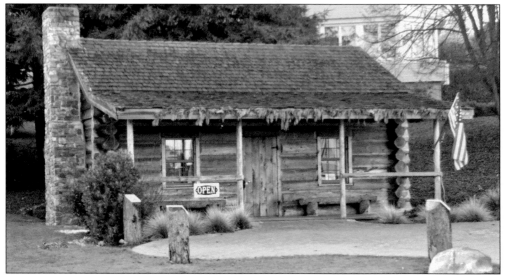

NEW JOB CARR CABIN. Old Tacoman Charlotte Naccarato was the first to suggest that Job Carr's cabin be returned to the neighborhood. The local business community ultimately saw the project through to completion. Using old photographs, a replica of Carr's original cabin was constructed in the Old Town Playground, where a museum now tells the story of Tacoma's beginnings.

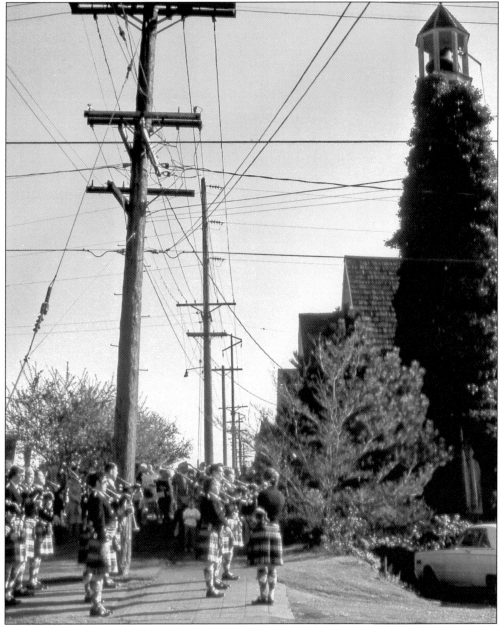

ST. PETER'S CHURCH. This history closes at the point of Old Tacoma's beginnings, the 1873 St. Peter's Episcopal Church. There have been physical changes to the building over time, but spiritually it remains the same. Services are held every Sunday in this historic National Register church, bag pipers celebrate weddings and mourn funerals, and the original bell still rings atop a cedar steeple. The continuity and change seen in this church is a perfect symbol for Old Tacoma as a whole. While there have been many changes in the neighborhood and along its shoreline, some things remain the same. New condominiums and business blocks have replaced the old, but some may achieve a significance of their own in the future, a simple reminder that history moves forward. And even though there has been change, the neighborhood will continue to tell the story of its past whenever it has a chance.